ACTION!

Professor Know-it-all's *illustrated* guide to film & video making

by Bill Brown

contents

foreward

WHEN I FIRST TOOK THE PLUNGE INTO MAKING
MY OWN MOVIES IN THE EARLY 90's (WAY
BACK IN THE 20TH CENTURY), I WORKED
WITH A PRETTY SIMPLE SET OF TOOLS : A
SUPER-8 CAMERA ON LOAN FROM MY UNCLE;
TRI-X BLACK & WHITE FILM (THE MOST
BEAUTIFUL FILM IN THE WORLD); AND A
BOOK RECOMMENDED TO ME BY ANOTHER
FILMMAKER, LENNY LIPTON'S INDEPENDENT
FILMMAKING . WITH ALL DUE RESPECT TO
MSSRS. ASCHER AND PINCUS, WHOSE
EXCELLENT FILMMAKER'S HANDBOOK, IN ITS
MANY ITERATIONS, HAS BEEN A GREAT
RESOURCE FOR ME OVER THE YEARS, MR.
LIPTON — UPFRONT, OPINIONATED, AND
SOMETIMES DOWNRIGHT CRANKY, BUT ALWAYS
CHARMING ; THE SUPPOSED CO-AUTHOR OF
"PUFF THE MAGIC DRAGON" — WAS THE
PERFECT GUIDE TO MY STARRY-EYED
INTRODUCTION TO MAKING MOTION PICTURES.

NOW IT'S 2011 AND I MUST SAY, WITH ALL
DUE RESPECT TO MR. LIPTON, THERE'S A NEW
BOOK AROUND FOR BOTH YOU PROSPECTIVE
FILMMAKERS AND VETERAN FILMMAKERS
WANTING TO BRUSH UP ON YOUR FACTS AND
TERMS. BILL BROWN, AKA PROF. KNOW-IT-
ALL, BRINGS THE EASE AND WARMTH OF

HIS MOVIE NARRATION AND DREAM WHIP
WRITINGS AND DRAWINGS TO THE NUTS AND
BOLTS OF WORKING WITH MOVIE FILM.
UNLIKE MOST KNOW-IT-ALLS WHOSE
I-TOLD-YOU-SO's CAN WEAR DOWN EVEN
THE MOST ENERGIZED AND DEDICATED, BILL
ACTS AS YOUR GENEROUS GUIDE AND
FELLOW TRAVELER, KEEPING THINGS STRAIGHT
FORWARD, PRACTICAL, WITH NO SHORTAGE
OF CHARM, ON THIS JOURNEY / ADVENTURE/
QUIXOTIC QUEST OF MAKING YOUR OWN
MOVIES IN THE 21ST CENTURY.

— THOMAS COMERFORD
 FILMMAKER, SONGWRITER, AND PROFESSOR
 IN THE DEPT. OF FILM, VIDEO, & NEW
 MEDIA AT THE SCHOOL OF THE ART
 INSTITUTE OF CHICAGO

intro

"WE FIND BEAUTY NOT IN THE THING ITSELF,
BUT IN THE PATTERN OF SHADOWS, THE
LIGHT AND THE DARKNESS, THAT ONE THING
AGAINST ANOTHER CREATES."

 — JUN'ICHIRŌ TANIZAKI

MY VERY FIRST FILM TEACHER TOLD ME THAT
MAKING MOVIES IS ONE PERCENT ART AND
NINETY-NINE PERCENT CRAFT. AT THE TIME,
I THOUGHT HE HAD IT EXACTLY BACKWARDS
AND I SPENT THE REST OF THE SEMESTER
TRYING TO IGNORE HIM. ONLY LATER, WHEN
I STARTED MAKING MOVIES, DID I REALIZE
THE GUY WAS RIGHT. EVEN IF YOU HAVE
A REALLY GREAT MOVIE IDEA IN YOUR HEAD,
IF YOU DON'T LEARN HOW TO EXPOSE YOUR
FILM OR COMPOSE A SHOT, YOU'LL HAVE
A TOUGH TIME TURNING YOUR GREAT IDEA
INTO A GREAT MOVIE. TO MAKE FILM ART,
FIRST YOU HAVE TO LEARN FILM CRAFT.

THIS LITTLE BOOK IS AN INTRODUCTION TO
FILM CRAFT. IT'LL TAKE YOU THROUGH THE
BASICS OF HOW 16MM FILM AND DIGITAL
VIDEO CAMERAS WORK; HOW TO LIGHT,

COMPOSE, AND EXPOSE YOUR SHOTS;
AND HOW TO RECORD AUDIO.

HUH?

THOUGH THIS BOOK
IS GEARED TO
BEGINNING FILM
MAKERS OF ALL
AGES, EVEN YOU
SMARTY PANTS
KNOW-IT-ALLS
OUT THERE MAY
LEARN A THING
OR TWO!

DON'T GET ME WRONG: MAKING MOVIES ISN'T
ONLY ABOUT CRAFT. HOLLYWOOD DIRECTORS
SEEM TO FORGET THIS SOMETIMES WHEN
THEY MAKE MOVIES THAT CAUSE OUR
EYEBALLS TO POP OR OUR EARS BLEED, BUT
THAT SHORTCHANGE OUR BRAINS OR OUR
HEARTS. SO LEARN YOUR FILM CRAFT, BUT
DON'T FORGET TO MAKE SOME GOOD ART!

the film camera

WHY LEARN HOW TO SHOOT FILM? I'M TALKING ABOUT FILM FILM: SPROCKET HOLES AND LIGHT SENSITIVE EMULSION. ISN'T EVERYTHING GOING DIGITAL? WELL, YOU COULD ALSO ASK WHY LEARN LATIN. IT'S A DEAD LANGUAGE, RIGHT?

LATIN IS BORING!

DON'T BE PUERILE. ☆

DON'T BE SUPERCILIOUS! ☆

☆ (FROM THE LATIN WORD PUER, MEANING CHILD)

☆ (FROM THE LATIN WORD SUPERCILIUM, MEANING EYEBROW.)

EVEN IF YOU SHOOT DIGITAL VIDEO AND NEVER TOUCH A FRAME OF FILM, MANY OF THE CONCEPTS YOU'LL BE DEALING WITH, NOT TO MENTION PLENTY OF THE TERMINOLOGY, COME DIRECTLY FROM THE WORLD OF FILMMAKING. SO IN THE SAME WAY THAT LEARNING LATIN GIVES YOU INSIGHT INTO HOW A LANGUAGE LIKE ENGLISH WORKS, LEARNING ABOUT FILM WILL HELP YOU

UNDERSTAND HOW EVEN THE MOST CUTTING EDGE DIGITAL VIDEO WORKS.

WHAT IS FILM, EXACTLY ? IF YOU WERE TO MAGNIFY IT ENOUGH, YOU'D SEE THAT IT'S MADE UP OF A LIGHT - SENSITIVE LAYER CALLED THE EMULSION THAT IS STUCK TO A LAYER OF PLASTIC CALLED THE BASE.

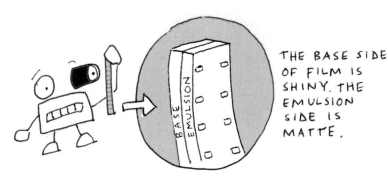

THE BASE SIDE OF FILM IS SHINY. THE EMULSION SIDE IS MATTE.

THE EMULSION IS MADE OF GELATIN. IN FACT, YOU CAN THINK OF THE EMULSION AS A JELLO MOLD. INSTEAD OF CHERRIES SUSPENDED IN THE GELATIN, HOWEVER, THERE ARE COUNTLESS LITTLE GRAINS OF LIGHT- SENSITIVE SILVER SALTS.

MOVIE FILM IS MADE UP OF A SERIES OF STILL PHOTOGRAPHS, ONE AFTER ANOTHER. UNTIL YOU RUN THE FILM THROUGH A MOVIE PROJECTOR, THAT'S ALL A FILM IS: A BIG ROLL OF STILL PHOTOS. SO HOW DO YOU GET MOTION PICTURES FROM A BUNCH OF MOTIONLESS PHOTOS? BEFORE WE GET TO THAT, LET'S TALK ABOUT HOW A FILM CAMERA WORKS.

THIS IS WHAT THE GUTS OF A MOVIE CAMERA LOOK LIKE:

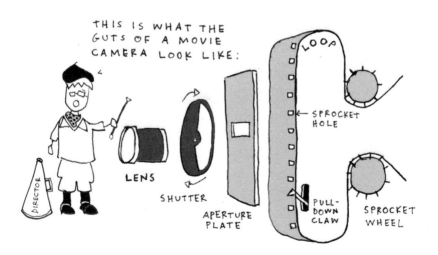

DIRECTOR

LENS

SHUTTER

APERTURE PLATE

LOOP

SPROCKET HOLE

PULL-DOWN CLAW

SPROCKET WHEEL

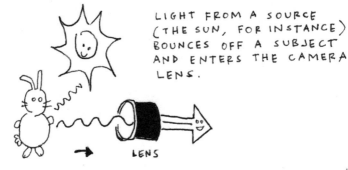

LIGHT FROM A SOURCE (THE SUN, FOR INSTANCE) BOUNCES OFF A SUBJECT AND ENTERS THE CAMERA LENS.

LENS

COME ON IN!

NEXT, THE LIGHT WAVES ENCOUNTER THE SHUTTER. THE SHUTTER IS LIKE A LITTLE DOOR. WHEN IT'S OPEN, LIGHT CAN PASS THROUGH AND REACH THE FILM.

GO AWAY!

WHEN IT'S CLOSED, IT CAN'T.

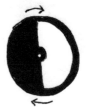

THE SHUTTER IS ACTUALLY A CIRCULAR DISK WITH A LITTLE OPENING THROUGH WHICH LIGHT CAN PASS.

SINCE THERE ARE 360
DEGREES IN A CIRCLE,
SHUTTERS ARE
MEASURED BY THE
NUMBER OF DEGREES
OF THE OPENING.

180° SHUTTER 90° SHUTTER

AS THE SHUTTER SPINS, IT
ALTERNATELY OPENS AND
CLOSES. WHEN IT'S OPEN,
LIGHT CAN PASS
THROUGH THE
APERTURE AND EXPOSE
THE FILM. WHEN THE
SHUTTER IS CLOSED,
LIGHT CAN'T.

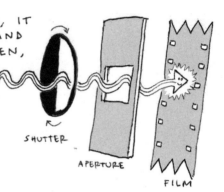

SHUTTER

APERTURE

FILM

BUT SOMETHING ELSE HAPPENS AS THE
SHUTTER SPINS THAT IS FUNDAMENTAL
TO THE WAY A MOVIE
CAMERA WORKS:
SOMETHING CALLED
INTERMITTENT
MOVEMENT.

intermittent movement

IF FILM MOVED CONTINUOUSLY PAST THE SHUTTER, THE INDIVIDUAL FILM FRAMES WOULDN'T HAVE A CHANCE TO BE SHARPLY EXPOSED. INSTEAD, YOUR FILM WOULD JUST BE A BIG BLUR.

INSTEAD, THE FILM MOVES PAST THE SHUTTER IN VERY QUICK STOPS AND STARTS. THANKS TO THE INTERMITTENT MECHANISM OF THE CAMERA, AT THE SAME MOMENT THE SHUTTER IS OPEN, A SINGLE FRAME OF FILM IS POSITIONED (OR REGISTERED) ON THE OTHER SIDE OF THE APERTURE WINDOW. THE FILM STOPS THERE FOR A FRACTION OF A SECOND, ALLOWING FOR A SHARP, STABLE EXPOSURE.

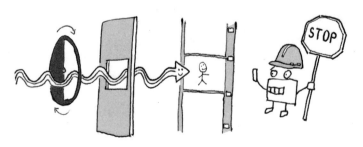

NEXT, THE SHUTTER SPINS TO ITS CLOSED
POSITION AND INSIDE THE CAMERA, IT GROWS
DARK... VERY DARK. THAT'S WHEN THE CLAW
EMERGES FROM ITS LAIR. THE CLAW GRABS A
SPROCKET HOLE AND ADVANCES THE FILM TO
THE NEXT UNEXPOSED FRAME, REGISTERING IT
JUST AS THE SHUTTER SPINS OPEN AGAIN.

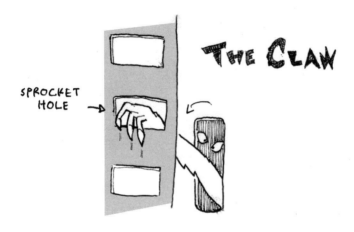

THE CLAW

SPROCKET
HOLE

AND SO IT GOES, FRAME AFTER FRAME. THE FILM
STOPS. THE SHUTTER OPENS. A FRAME IS
EXPOSED. THE SHUTTER CLOSES. THE CLAW
PULLS DOWN THE NEXT FRAME. THIS IS THE
INTERMITTENT MOVEMENT MAGIC OF THE
MOVIE CAMERA.

BY TAKING LOTS OF PICTURES REALLY FAST,
A MOVIE CAMERA IS ABLE TO TRANSLATE
CONTINUOUS MOVEMENTS OUT IN THE
WORLD INTO A SERIES OF STILL
PHOTOGRAPHS ON THE FILM.

A SERIES OF STILL PHOTOS

A CONTINUOUS MOVEMENT

A MOVIE CAMERA RUNNING AT
NORMAL SPEED TAKES 24
PICTURES EVERY SECOND.
FILMMAKERS REFER TO THIS
SPEED AS 24 FRAMES PER
SECOND, OR 24 FPS. WHEN YOU
SHOOT AT 24 FPS, MOVEMENT
APPEARS NOT TOO FAST AND
NOT TOO SLOW, BUT JUST RIGHT.
FOR FILMMAKERS, 24 IS A
MAGIC NUMBER.

IT TURNS OUT THAT 24 IS A PRETTY ARBITRARY NUMBER. IN THE EARLY DAYS OF CINEMA, CAMERA OPERATORS TRIED TO SHOOT AT AROUND 16 FPS. ANY LESS THAN THAT RESULTED IN FLICKERY MOVIES (HENCE THE TERM "FLICKS"). BUT SINCE MOVIE CAMERAS WERE HAND-CRANKED, CAMERA SPEEDS COULD VARY GREATLY. THIS CAUSED ALL SORTS OF PROBLEMS FOR FILM PROJECTIONISTS.

AT WHAT SPEED DID YOU SHOOT THIS FILM?!

YOU NAME IT, BUB.

CAMERA MAN

PROJECTIONIST

IT WASN'T TILL THE ADVENT OF SOUND FILMS IN THE LATE 1920's THAT CINEMA ENGINEERS DECIDED THEY NEEDED A STANDARD FILM SPEED. 24 FPS WAS THE NUMBER THEY MORE OR LESS PULLED OUT OF THEIR HAT.

WHAT ABOUT THE FILM PROJECTOR — HOW DOES IT
WORK? LIKE A MOVIE CAMERA, A MOVIE
PROJECTOR'S MECHANISM IS BASED ON
INTERMITTENT MOVEMENT: EACH FRAME OF FILM
PAUSES FOR $\frac{1}{24}$ OF A SECOND IN FRONT OF THE
APERTURE, THEN THE SHUTTER SPINS OPEN
(USUALLY, IT SPINS OPEN TWICE PER FRAME
WHICH HELPS TO REDUCE IMAGE FLICKER),
ALLOWING THE PROJECTOR LAMP TO SHINE
THROUGH THE FILM AND PROJECT AN IMAGE ON
THE SCREEN.

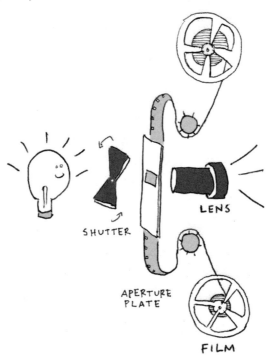

SHUTTER

LENS

APERTURE
PLATE

FILM

YOU CAN THINK OF A FILM PROJECTOR AS A FILM CAMERA IN REVERSE. A CAMERA TURNS MOVEMENT INTO A SERIES OF STILL IMAGES. A PROJECTOR TURNS STILL IMAGES BACK INTO MOVEMENT.

CINÉMATOGRAPHE

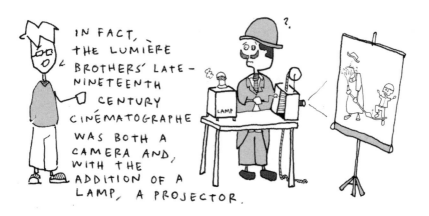

IN FACT, THE LUMIÈRE BROTHERS' LATE-NINETEENTH CENTURY CINÉMATOGRAPHE WAS BOTH A CAMERA AND, WITH THE ADDITION OF A LAMP, A PROJECTOR.

SO THAT'S HOW THE MOVIE CAMERA WORKS AND
THAT'S HOW THE MOVIE PROJECTOR WORKS,
BUT WE STILL HAVEN'T ANSWERED THE
BIG QUESTION : HOW DO MOVIES WORK?

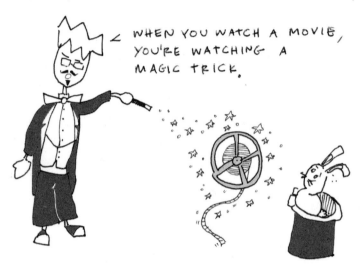

WHEN YOU WATCH A MOVIE,
YOU'RE WATCHING A
MAGIC TRICK.

THE MAGIC TRICK HAS TWO PARTS. THE FIRST
PART HAS TO DO WITH FLICKER. IMAGINE
IF YOU SLOWED DOWN THE FILM PROJECTOR
SO IT RAN THE FILM REALLY SLOW. WHAT
YOU'D SEE IS AN ALTERNATING SERIES OF
STILL IMAGES (WHEN THE SHUTTER OPENS)
AND BLACK (WHEN THE SHUTTER CLOSES).
IT WOULD BE LIKE WATCHING A SLIDE
SHOW INSTEAD OF A MOVIE.

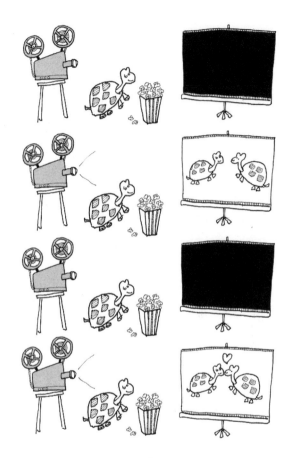

NOW SPEED UP THE PROJECTOR. AT A CERTAIN
SPEED THE FLICKER WILL DISAPPEAR, AND THE
BRIGHTNESS OF THE IMAGE WILL APPEAR
STEADY. THIS MAGICAL MOMENT IS CALLED

FLICKER FUSION.

THE SECOND PART OF THE MAGIC TRICK IS THE ILLUSION OF APPARENT MOTION.

IN THE EARLY 20TH CENTURY, THE PSYCHOLOGIST MAX WERTHEIMER OBSERVED THAT WHEN HE SHOWED PEOPLE TWO SLIDES IN QUICK SUCCESSION — ONE SLIDE OF A BALL ON THE LEFT SIDE OF THE SCREEN, THE OTHER SLIDE OF A BALL ON THE RIGHT SIDE OF THE SCREEN — MOST PEOPLE WOULD REPORT THAT THEY SAW THE BALL MOVE FROM SCREEN LEFT TO SCREEN RIGHT.

OF COURSE, NOTHING HAD ACTUALLY MOVED. IT'S AN OPTICAL ILLUSION; OR MORE PRECISELY, A NEURO-PHYSIOLOGICAL ILLUSION.

WHEN YOU WATCH MOVIES, YOUR EYES
RECEIVE VISUAL INFORMATION THAT
THEY CONVERT TO SIGNALS THAT ARE
SENT TO YOUR BRAIN.

WHOA!

CHECK
THIS OUT,
BRAIN!

THEN IT'S UP TO YOUR BRAIN
TO MAKE SENSE OF THAT
INFORMATION. YOUR
BRAIN CONNECTS THE
DOTS AND FILLS IN
THE GAPS. IT TURNS
STILL IMAGES INTO
MOVING IMAGES. IN A
VERY REAL SENSE, A MOVIE
IS ALL IN YOUR HEAD.

15

- HA.

brain tickler

ACROSS

4. SPINNING DISK IN CAMERA THAT ALLOWS LIGHT TO REACH THE FILM.

6. MOTION IN A MOTION PICTURE IS AN OPTICAL _____.

7. "MAGIC MOMENT" WHEN BRIGHTNESS OF MOVIE IMAGE APPEARS CONSTANT (SEE 9 ACROSS).

8. FILM STRIP IS MADE UP OF A SERIES OF _____ IMAGES.

9. SEE 7 ACROSS.

DOWN

1. LIGHT SENSITIVE LAYER OF FILM.

2. "NORMAL SPEED, 24 _____ PER SECOND.

3. "STOP-START" MECHANISM OF MOVIE CAMERA IS CALLED _____ MOVEMENT.

5. IT GRABS THE NEXT FRAME.

movie film

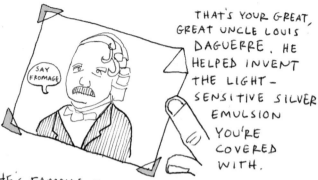

THAT'S YOUR GREAT, GREAT UNCLE LOUIS DAGUERRE. HE HELPED INVENT THE LIGHT-SENSITIVE SILVER EMULSION YOU'RE COVERED WITH.

HE'S FAMOUS FOR COPPER PLATE PHOTOS CALLED DAGUERREOTYPES.

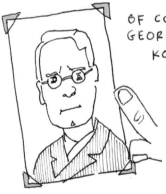

OF COURSE, THAT'S YOUR GRANDAD GEORGE EASTMAN. HE FOUNDED KODAK. HE ALSO INVENTED ROLL FILM, I.E. FILM WITH A PLASTIC BASE THAT COULD BE WOUND INTO ROLLS. WITHOUT ROLL FILM, THERE WOULDN'T BE MOVIE FILM.

AND HERE'S CHARLES-ÉMILE REYNAUD, YOUR CRAZY COUSIN. HE CAME UP WITH THE IDEA OF SPROCKET HOLES. WITHOUT HIM, YOU WOULDN'T MOVE.

Choosing your film

FILM COMES IN ALL SORTS OF FLAVORS.

IN THIS AGE OF DIGITAL IMAGING, THERE DEFINITELY AREN'T AS MANY KINDS OF MOVIE FILM AS THERE ONCE WERE. SOME, LIKE KODACHROME, KODAK'S CLASSIC REVERSAL FILM, ARE SORELY MISSED. EVEN SO, THERE ARE STILL PLENTY OF OPTIONS.

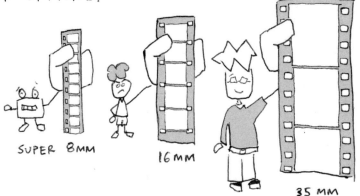

SUPER 8MM

16MM

35 MM

MOVIE FILM COMES IN DIFFERENT SIZES, CALLED GAUGES. THE GAUGE REFERS TO THE WIDTH OF THE FILM, E.G. 16MM FILM IS 16 MILLIMETERS WIDE. HOME MOVIES USED TO BE SHOT ON SUPER 8. MOST MOVIES YOU WATCH AT THE CINEPLEX ARE 35MM, AKA "STANDARD GAUGE."

19

Negative vs. Reversal

FILM STOCK CAN BE NEGATIVE OR REVERSAL.
WHEN YOU SHOOT WITH NEGATIVE STOCK, THE
FILM YOU RUN THROUGH YOUR CAMERA
BECOMES A PHOTOGRAPHIC NEGATIVE. THE
NEGATIVE THEN NEEDS TO BE PRINTED ONTO
A NEW ROLL OF FILM TO MAKE A
POSITIVE IMAGE.

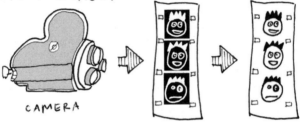

CAMERA

WHEN YOU SHOOT REVERSAL, YOU GET
POSITIVE IMAGES RIGHT AWAY.

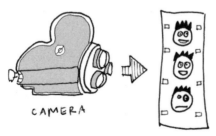

CAMERA

EACH TYPE OF FILM HAS ITS ADVANTAGES
AND DISADVANTAGES:

REVERSAL

JUST CALL ME MR. POSITIVE!

PRO

1. WHAT YOU SHOOT BECOMES A POSITIVE, YOU AVOID THE EXTRA STEP (AND EXPENSE) OF MAKING A NEW POSITIVE FROM A NEGATIVE.

2. BLACK AND WHITE REVERSAL IS HIGH CONTRAST WITH STRONG BLACKS. IT'S A NICE LOOK IF THAT'S WHAT YOU'RE AIMING FOR.

3. COLOR REVERSAL HAS SATURATED COLORS. AGAIN, A NICE LOOK IF THAT'S WHAT YOU WANT.

1. REVERSAL DOESN'T HAVE A GREAT DEGREE OF LATITUDE, A TERM THAT REFERS TO THE RANGE OF EXPOSURES THE FILM CAN REPRODUCE. REVERSAL IS NOT VERY FORGIVING IF YOU OVER OR UNDER EXPOSE IT.

CON

2. BECAUSE THE FILM YOU SHOOT BECOMES A POSITIVE, YOU DON'T HAVE A BACK-UP COPY. THAT SAID, YOU CAN TRANSFER

YOUR FOOTAGE TO VIDEO AND SAFELY
STASH AWAY YOUR ORIGINALS.

NEGATIVE

I'M NOT
NEGATIVE.
I'M JUST
REALISTIC.

PRO

1. NEGATIVE FILM HAS MORE EXPOSURE
 LATITUDE THAN REVERSAL, SO IT'S
 EASIER TO EXPOSE. MOREOVER, WHEN
 YOU MAKE A POSITIVE FROM THE
 NEGATIVES, YOU HAVE ANOTHER
 OPPORTUNITY TO ADJUST THE EXPOSURES.

2. BECAUSE YOU MAKE A POSITIVE PRINT
 FROM YOUR NEGATIVES, YOU CAN EDIT
 OR PROJECT THE POSITIVE (CALLED
 A WORKPRINT) WHILE KEEPING YOUR
 NEGATIVE SAFELY STASHED AWAY.

1. NEGATIVE FILM REQUIRES THE
 ADDITIONAL STEP (AND
 EXPENSE) OF MAKING A
 POSITIVE PRINT.

CON

Black & White vs. Color

FILM STOCK CAN BE BLACK AND WHITE OR COLOR.

BLACK AND WHITE FILM CONSISTS OF THREE LAYERS: A LIGHT-SENSITIVE EMULSION, A PLASTIC BASE THAT HOLDS THE EMULSION, AND AN ANTI-HALATION LAYER THAT ABSORBS LIGHT THAT PASSES THROUGH THE FIRST TWO LAYERS, PREVENTING IT FROM FOGGING THE FILM.

COLOR FILM IS A BIT MORE COMPLICATED. IT HAS THREE EMULSION LAYERS, EACH SENSITIVE TO A PARTICULAR PART OF THE COLOR SPECTRUM: RED, GREEN, AND BLUE.

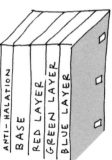

THE EMULSION IS A LAYER OF GELATIN WITH LITTLE GRAINS OF LIGHT-SENSITIVE SILVER SALT FLOATING IN IT. THE SIZE OF THOSE GRAINS DETERMINES HOW SENSITIVE THE FILM IS TO LIGHT: THE SMALLER THE GRAIN, THE LESS SENSITIVE, THE BIGGER THE GRAIN, THE MORE SENSITIVE.

THE MEASUREMENT OF A FILM'S SENSITIVITY TO LIGHT IS ITS SPEED.

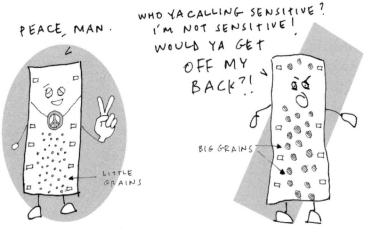

PEACE, MAN.

LITTLE GRAINS

WHO YA CALLING SENSITIVE? I'M NOT SENSITIVE! WOULD YA GET OFF MY BACK?!

BIG GRAINS

SLOW SPEED FILM IS LESS SENSITIVE.

FAST SPEED FILM IS MORE SENSITIVE.

SO WHICH FILM
DO I PICK?

GENERALLY, FOR BRIGHTLY
LIT SITUATIONS, YOU'D
CHOOSE A SLOWER FILM;
FOR LOW LIGHT
SITUATIONS, A
FASTER FILM.

ALSO KEEP IN MIND THAT THE FILM YOU
CHOOSE HAS A LOT TO DO WITH THE
"LOOK" YOU WANT. BECAUSE FASTER
FILMS HAVE BIGGER GRAINS OF SILVER,
THEY TEND TO LOOK GRAINIER THAN
SLOWER, FINER GRAINED FILMS.

WHEN YOU BUY FILM, YOU CAN DETERMINE ITS
SPEED BY LOOKING AT ITS EXPOSURE INDEX
(E.I.) NUMBER. THE LOWER THE E.I., THE
SLOWER THE FILM. THE HIGHER THE E.I.,
THE FASTER THE FILM.

HERE IS A BOX OF KODAK PLUS-X 16mm
MOVIE FILM.

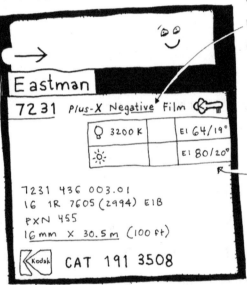

"PLUS-X" IS A
BLACK AND WHITE
NEGATIVE FILM.

HERE'S WHERE
YOU FIND INFO
ABOUT THE
FILM'S SPEED.
NOTICE THAT
IN DAYLIGHT
(☀), THE E.I.
IS 80, WHILE
IN TUNGSTEN
LIGHT (💡),
IT'S 64.

F.Y.I. : YOU COULD WRITE A WHOLE BOOK
ABOUT THESE FILM SPEED NUMBERS.
JUST REMEMBER THAT YOUR E.I. IS USUALLY
INDICATED BY TWO NUMBERS SEPARATED
BY A SLASH. THE NUMBER ON THE LEFT

26

(THE ASA OR ANSI NUMBER) IS THE ONE
TO WATCH IF YOU'RE IN THE U.S.A. THE
NUMBER ON THE RIGHT IS ITS METRIC
EQUIVALENT, THE DIN NUMBER. IT'S
MEASURED IN DEGREES.

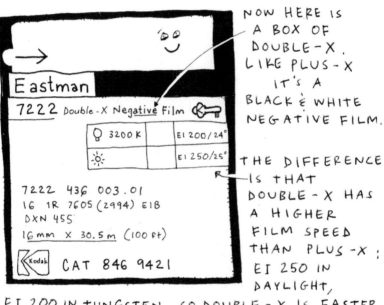

NOW HERE IS
A BOX OF
DOUBLE-X.
LIKE PLUS-X
IT'S A
BLACK & WHITE
NEGATIVE FILM.

THE DIFFERENCE
IS THAT
DOUBLE-X HAS
A HIGHER
FILM SPEED
THAN PLUS-X:
EI 250 IN
DAYLIGHT,

EI 200 IN TUNGSTEN. SO DOUBLE-X IS FASTER
THAN PLUS-X.

ALSO NOTICE THAT BOTH FILMS ARE
SLIGHTLY MORE SENSITIVE TO OUTDOOR
LIGHT THAN INDOOR LIGHT. MORE ON
THIS IN A SECOND.

Tungsten vs. Daylight

"WHITE" LIGHT IS ACTUALLY MADE UP OF
THREE PRIMARY COLORS: RED, GREEN,
AND BLUE. DIFFERENT LIGHT SOURCES
HAVE DIFFERENT PROPORTIONS OF THESE
COLORS.

OUR EYES ARE PRETTY EASYGOING ABOUT
THESE DIFFERENCES. SUNSHINE LOOKS WHITE
TO US, BUT SO DOES AN INCANDESCENT
LIGHTBULB.

LOOKS WHITE TO ME.

NOT SO FOR COLOR FILM AND VIDEO. THEY
ARE SENSITIVE TO THESE DIFFERENCES
AND MUST BE "BALANCED" FOR THE TYPE
OF LIGHT YOU'RE SHOOTING IN.

EVERY LIGHT SOURCE HAS A "COLOR TEMPER-
ATURE" THAT CAN BE EXPRESSED IN
DEGREES KELVIN (K), A UNIT NAMED
AFTER THE SCOTTISH PHYSICIST WILLIAM
KELVIN.

KELVIN DISCOVERED THAT WHEN HE HEATED
A BLOCK OF CARBON, IT CHANGED COLOR.
AS THE TEMPERATURE ROSE, THE CARBON
WENT FROM BLACK TO RED TO BLUE TO
WHITE HOT. SO COLOR TEMPERATURE CAN
TELL YOU SOMETHING ABOUT THE COLOR
OF A LIGHT SOURCE. THE LOWER THE
COLOR TEMPERATURE, THE REDDER THE
LIGHT. THE HIGHER THE COLOR TEMP.,
THE BLUER THE LIGHT.

FOR INSTANCE, STANDARD TUNGSTEN (INDOOR) LIGHT IS 3200°K, WHICH HAS AN ORANGISH HUE. DAYLIGHT IS 5500°K AND HAS A BLUISH HUE.

HERE ARE A COUPLE TYPES OF COLOR NEGATIVE FILM. ON THE LABELS, YOU'LL FIND THE <u>FILM SPEED</u> AND THE <u>FILM TYPE</u> SEPARATED BY A SLASH: 500T/7219 AND 50D/7201.

Kodak
VISION3
color Negative Film

500T/7219

💡 3200K		EI 500/28°
☀️	Filter No. 85	EI 320/26°

Kodak
VISION2

50D / 7201

💡 3200K	Filter No. 80A	EI 12/12°
☀️		EI 50/18°

SO WHAT DO THE "T" AND THE "D"
STAND FOR? THE "T" LETS YOU KNOW
THAT 7219 IS A TUNGSTEN-BALANCED
FILM. THE "D" LETS YOU KNOW THAT
7201 IS A DAYLIGHT-BALANCED FILM.

TUNGSTEN-BALANCED FILMS ARE MADE
WITH EMULSIONS THAT ARE BALANCED
FOR THE ORANGISH HUE OF TUNGSTEN
LIGHT, ALLOWING THE COLORS TO
COME OUT AS "NEUTRAL" OR
"NATURAL." LIKEWISE, DAYLIGHT
FILMS ARE BALANCED FOR THE BLUISH
HUE OF DAYLIGHT.

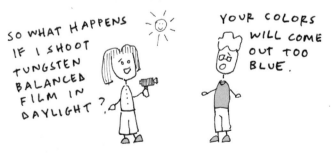

SO WHAT HAPPENS
IF I SHOOT
TUNGSTEN
BALANCED
FILM IN
DAYLIGHT?

YOUR COLORS
WILL COME
OUT TOO
BLUE.

WE'RE COLOR CONVERSION FILTERS
YO! AND CONVERTIN'S WHAT WE DO!
WE TAKE THE LIGHT AND MAKE IT RIGHT
FOR THE FILM YOU WANT TO USE!

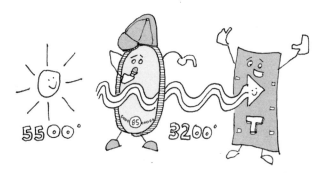

MY NUMBER IS 85, AN' I'M ORANGE AS YOU CAN
SEE, I TAKE DAYLIGHT AND <u>COOL</u> <u>IT</u> <u>DOWN</u>
TO 3200 KELVIN DEGREE!

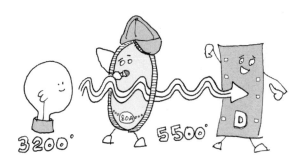

I'M NO. 80A, BUT YOU CAN CALL ME "BLUE!"
KICKIN' TUNGSTEN LIGHT TO 55-HUNDRED
HEIGHT IS WHAT I LIKE TO DO!

TAKE A LOOK AT THE COLOR FILM
LABELS AGAIN :

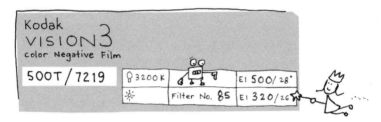

FOR THE TUNGSTEN - BALANCED FILM,
THE EI IS A SPEEDY 500. BUT LOOK
WHAT HAPPENS IF YOU PUT A NO. 85
COLOR CONVERSION FILTER ON YOUR
LENS. THE EI IS NOW 320, ABOUT
$\frac{2}{3}$ LESS SENSITIVE.

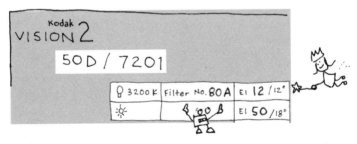

SAME FOR THE DAYLIGHT - BALANCED
FILM. THE EI IS A FAIRLY SLOW 50
IN DAYLIGHT, BUT A POSITIVELY
GLACIAL 12 WHEN YOU SHOOT
THROUGH AN 80A FILTER.

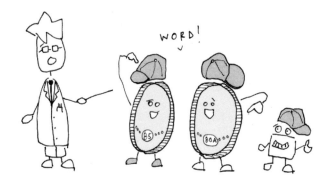

MANY TYPES OF FILTERS THAT YOU PUT
ON YOUR LENS WILL ABSORB LIGHT,
SOME FILTERS MORE THAN OTHERS.
THIS IS CALLED THE FILTER FACTOR.
AN 85 FILTER ABORBS 2/3 OF A STOP, FOR
EXAMPLE; AN 80A ABSORBS 2 STOPS.
WHEN YOU EXPOSE YOUR FILM, YOU ALWAYS
HAVE TO REMEMBER TO COMPENSATE FOR
THE FILTER FACTOR.

A NEUTRAL DENSITY (ND) FILTER, ON THE
OTHER HAND, IS DESIGNED ESPECIALLY TO
REDUCE THE AMOUNT OF LIGHT ENTERING THE
LENS. YOU CAN THINK OF AN ND FILTER AS
SUNGLASSES FOR YOUR LENS. IT'S A VERY
HANDY FILTER TO HAVE WHEN YOU'RE
SHOOTING IN A PARTICULARLY BRIGHT
SITUATION.

- HA.

brain tickler 2.

ACROSS

2. MEASUREMENT OF FILM'S SENSITIVITY TO LIGHT.

5. SIZE OF FILM STOCK, MEASURED IN MM.

6. COLOR TEMPERATURE IS MEASURED IN DEGREES _____ .

DOWN

1. THE HIGHER THE E.I. NUMBER, THE _____ SENSITIVE THE FILM TO LIGHT.

3. PHOTO PIONEER LOUIS.

4. PUT IT ON YOUR LENS TO CORRECT COLOR OR REDUCE EXPOSURE.

5. A BIT OF LIGHT SENSITIVE SILVER SALT.

the lens

YOU CAN THINK OF THE LENS AS THE CAMERA'S EYEBALL. IT RECEIVES LIGHT FROM THE WORLD AND FOCUSES IT INTO AN IMAGE.

A CAMERA "LENS" IS ACTUALLY A COLLECTION OF A NUMBER OF LENSES, CALLED ELEMENTS. SOME LENSES HAVE A DOZEN OR MORE ELEMENTS.

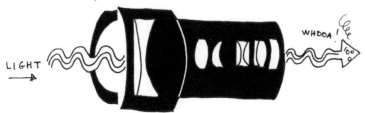

LIGHT

WHOOA!

A ZOOM LENS WITH ITS ELEMENTS SHOWING

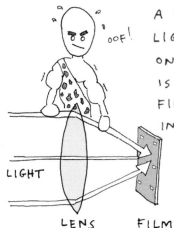

A LENS REFRACTS (BENDS) LIGHT, FOCUSING AN IMAGE ON THE F<u>OCAL</u> PL<u>ANE</u> WHICH IS WHERE YOU FIND THE FILM, OR THE SENSOR CHIP IN A VIDEO CAMERA.

LIGHT

LENS FILM

LENSES ARE IDENTIFIED BY THEIR F<u>OCAL</u> L<u>ENGTH</u>. IN TECHNICAL TERMS, FOCAL LENGTH IS THE DISTANCE FROM THE OPTICAL CENTER OF THE LENS TO THE FOCAL PLANE. BUT IN PRACTICAL TERMS, FOCAL LENGTH TELLS YOU HOW LARGE A GIVEN OBJECT WILL APPEAR IN THE LENS.

A NORMAL LENS FOR A 16mm MOVIE CAMERA HAS A FOCAL LENGTH IN THE NEIGHBORHOOD OF 25mm. IT'S "NORMAL" BECAUSE IT MORE OR LESS REPRODUCES HOW OUR EYE PERCEIVES AN OBJECT.

A WIDE ANGLE LENS IS LESS THAN 25mm. BECAUSE IT HAS A WIDER ANGLE OF VIEW, A

GIVEN OBJECT APPEARS SMALLER THAN WITH
A NORMAL LENS.

A TELEPHOTO LENS IS MORE THAN 25mm.
BECAUSE IT HAS A NARROWER ANGLE OF
VIEW, A GIVEN OBJECT APPEARS LARGER
THAN WITH A NORMAL LENS.

DISTANCE TO SUBJECT REMAINS THE SAME.

WIDE ANGLE NORMAL TELEPHOTO

A WIDE-ANGLE LENS LETS YOU "FIT" MORE
INTO THE FRAME. IT'S ALSO GREAT FOR
SUGGESTING THE SPACIOUSNESS OF WHAT
YOU'RE SHOOTING – A WESTERN LANDSCAPE,
FOR INSTANCE.

WIDE

A TELEPHOTO LENS LETS YOU PICK OUT DETAILS
OF THINGS THAT ARE FAR AWAY – SAY, A RARE
SONGBIRD THAT IS HIGH UP IN A TREE.

TELEPHOTO

BOTH WIDE-ANGLE AND TELEPHOTO LENSES
CAN DISTORT VISUAL PERSPECTIVE.
THESE EFFECTS MAY BE SOMETHING YOU
WANT TO ACHIEVE OR AVOID.

A WIDE ANGLE LENS CAN DISTORT FACIAL
FEATURES WHEN POSITIONED CLOSE TO A
SUBJECT:

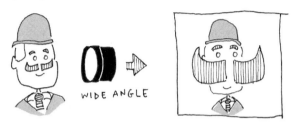

IT CAN ALSO EXAGGERATE THE DISTANCE
BETWEEN THE FOREGROUND AND BACKGROUND:

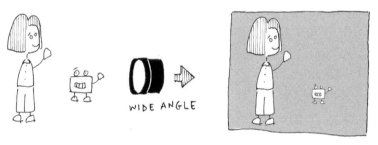

A TELEPHOTO LENS, ON THE OTHER HAND,
COMPRESSES FOREGROUND AND BACKGROUND
SPACE:

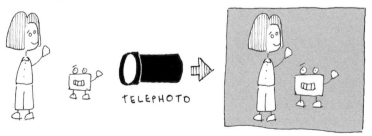

LENSES CAN BE PRIME OR ZOOM. A PRIME
LENS HAS A SINGLE, FIXED FOCAL LENGTH.
A ZOOM LENS, ON THE OTHER HAND, HAS
A VARIABLE FOCAL LENGTH.

THE BIG ADVANTAGE OF A ZOOM LENS IS THAT
ONE LENS CAN DO THE WORK OF A LOT OF
PRIME LENSES. A ZOOM WITH A RANGE OF
12mm TO 120mm, FOR INSTANCE, CAN GO
FROM WIDE-ANGLE TO TELEPHOTO (OR ANY
FOCAL LENGTH IN BETWEEN) WITH JUST A
TURN OF THE ADJUSTMENT RING.

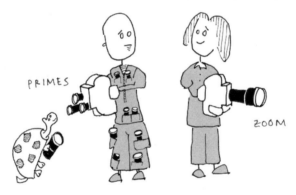

BUT PRIME LENSES HAVE THEIR FANS.
PRIMES MAKE EXTREMELY SHARP IMAGES.
THEY ALSO TEND TO BE FASTER THAN
ZOOM LENSES, I.E., THEY LET MORE LIGHT
PASS THROUGH. THIS CAN BE HELPFUL IN
LOW-LIGHT SITUATIONS.

APERTURE

YOUR PUPIL CONTROLS THE AMOUNT OF LIGHT
THAT ENTERS YOUR EYE. WHEN IT'S DARK,
YOUR PUPIL DILATES, OR OPENS UP, TO
ALLOW MORE LIGHT IN. WHEN IT'S BRIGHT,
YOUR PUPIL CONTRACTS.

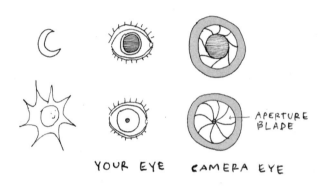

YOUR EYE CAMERA EYE

A LENS HAS A PUPIL, TOO, CALLED THE
APERTURE. A NUMBER OF OVERLAPPING BLADES
CONTROL THE SIZE OF THE APERTURE. IT CAN BE
OPENED UP TO ALLOW MORE LIGHT TO PASS
THROUGH THE LENS, OR CLOSED DOWN TO
ALLOW LESS LIGHT.

THE SIZE OF THE LENS APERTURE — HOW WIDE
IT'S OPENED — IS MEASURED IN UNITS
CALLED F-STOPS. F-STOP IS SIMPLY THE

FOCAL LENGTH OF THE LENS DIVIDED BY THE
DIAMETER OF THE APERTURE. CONVENIENTLY,
THESE NUMBERS ARE MARKED ON YOUR
LENS.

F-STOPS ARE A WAY TO EXPRESS HOW MUCH
LIGHT IS ENTERING THE LENS AND,
ULTIMATELY, EXPOSING THE FILM. THE
LOWER THE F-STOP, THE WIDER THE
APERTURE, AND THE MORE LIGHT; THE
HIGHER THE F-STOP, THE SMALLER THE
APERTURE, AND THE LESS LIGHT.

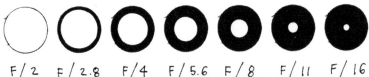

F/2 F/2.8 F/4 F/5.6 F/8 F/11 F/16

A TYPICAL LENS HAS A RANGE OF F-STOPS
FROM F/2 TO F/16, THOUGH THIS VARIES
BY THE LENS. SOME LENSES OPEN A
LITTLE WIDER, SOME CLOSE A LITTLE MORE.

LENS SPEED IS INDICATED BY THE LOWEST
F-STOP A LENS CAN BE SET TO. A
"FASTER" LENS ALLOWS MORE LIGHT
TO PASS THROUGH IT THAN A "SLOWER"
LENS.

AS A RULE, PRIME LENSES TEND TO BE
FASTER THAN ZOOM LENSES, AND LENSES
WITH SHORTER FOCAL LENGTHS TEND TO BE
FASTER THAN LONGER LENSES.

F-STOP MATH IS EASY! EVERY TIME YOU OPEN
THE APERTURE ONE STOP, YOU DOUBLE THE
AMOUNT OF LIGHT PASSING THROUGH THE
LENS. WHEN YOU CLOSE THE APERTURE ONE
STOP, YOU HALVE THE AMOUNT OF LIGHT.

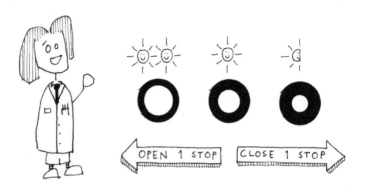

REMEMBER LOGARITHMS? F-STOPS ARE LOGARITHMIC TO BASE 2.

OPEN 1 STOP: $2^1 = 2$ (SO YOU DOU<u>BLE</u> THE LIGHT)
OPEN 2 STOPS: $2^2 = 4$ (YOU QUAD<u>RU</u>PLE THE LIGHT),

ETC. IT WORKS THE OTHER WAY, TOO:

CLOSE 1 STOP: $2^{-1} = \frac{1}{2}$ (YOU HA<u>LVE</u> THE LIGHT)
CLOSE 2 STOPS: $2^{-2} = \frac{1}{4}$ (YOU QUA<u>RTER</u> THE LIGHT),
ETC.

'WOOHOO!

Something you learned in high school math class that actually has a real world application!!

focus

FOCUS IS<u>N</u>'T LIKE A LIGHT SWITCH -- FLIP IT ONE WAY, YOUR IMAGE IS NICE AND SHARP, FLIP IT THE OTHER, IT'S BLURRY. INSTEAD, FOCUS IS A <u>RANGE</u>, AND A SINGLE IMAGE CAN CONTAIN ELEMENTS THAT ARE <u>ACCEPTABLY</u> SHARP AND ELEMENTS THAT ARE NOT.

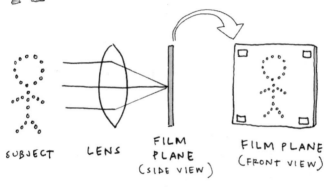

SUBJECT LENS FILM PLANE (SIDE VIEW) FILM PLANE (FRONT VIEW)

THINK OF YOUR SUBJECT AS A COLLECTION OF POINTS A CERTAIN DISTANCE FROM YOUR CAMERA. WHEN YOU FOCUS YOUR LENS AT THAT DISTANCE, ALL THOSE POINTS APPEAR AS NICE, SHARP POINTS OF FOCUS ON YOUR FILM. BUT, ALAS, THINGS ARE MORE COMPLICATED THAN THIS. SINCE THE WORLD IS <u>THREE-DIMENSIONAL</u>, SOME OF THE POINTS ARE A BIT CLOSER TO YOUR CAMERA,

47

AND SOME POINTS ARE A BIT FARTHER AWAY.
THOSE OUTLYING POINTS WON'T APPEAR AS
POINTS OF FOCUS ON YOUR FILM, BUT AS
CIRCLES :

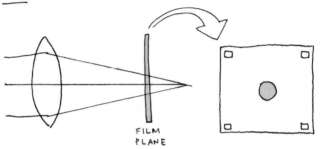

A POINT THAT IS A BIT CLOSER THAN THE FOCUS
DISTANCE OF THE LENS APPEARS AS A CIRCLE.

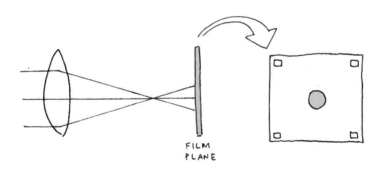

A POINT THAT IS A BIT FARTHER THAN THE FOCUS
DISTANCE OF THE LENS APPEARS AS A CIRCLE.

THESE CIRCLES ARE CALLED CIRCLES OF
CONFUSION, OR C.O.C.*

* NOT TO BE CONFUSED
WITH THE EIGHTIES
HARDCORE BAND
"CORROSION OF
CONFORMITY."

FORTUNATELY, OUR EYES AREN'T VERY
FINICKY. AS LONG AS THESE CIRCLES AREN'T
TOO BIG, OUR EYES WILL PERCEIVE THEM
AS POINTS OF FOCUS.

IT ALL LOOKS
IN FOCUS
TO ME!

DUDE, YOU
NEED GLASSES.

SO WHAT WE PERCEIVE AS "ACCEPTABLE"
FOCUS EXTENDS IN FRONT OF AND BEHIND
THE SUBJECT WE'RE FOCUSING ON.
THIS ZONE OF FOCUS IS CALLED
DEPTH OF FIELD.

DEPTH OF FIELD CAN BE INCREASED OR
DECREASED DEPENDING ON HOW MUCH OF THE
SCENE YOU WANT TO BE IN FOCUS. FOR
INSTANCE, SAY YOU WANT THE VIEWER TO
PAY ATTENTION TO A PARTICULAR ELEMENT
OF A SCENE, YOU MAY DECIDE TO
DECREASE THE DEPTH SO ONLY THAT
ELEMENT IS IN FOCUS :

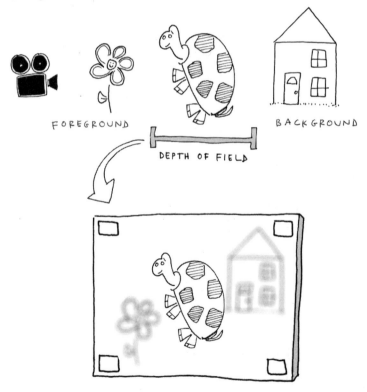

FOREGROUND

DEPTH OF FIELD

BACKGROUND

OR YOU MAY DECIDE TO INCREASE THE DEPTH
SO MORE OF THE SCENE IS IN FOCUS.

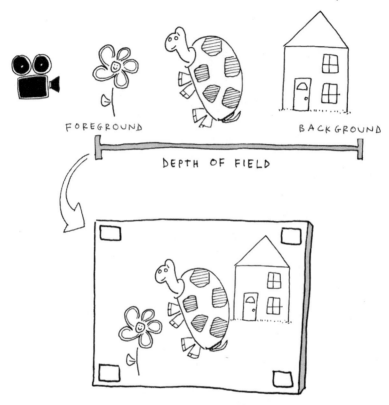

ORSON WELLES FAMOUSLY SHOT MANY
SCENES IN CITIZEN KANE (1941) USING
"DEEP FOCUS," I.E. A GREAT DEAL OF
DEPTH OF FIELD. THIS ALLOWS THE
VIEWER TO SIMULTANEOUSLY WATCH

THE ACTION UNFOLD IN THE NEAR
FOREGROUND AND DISTANT BACKGROUND
OF THE SAME SHOT.

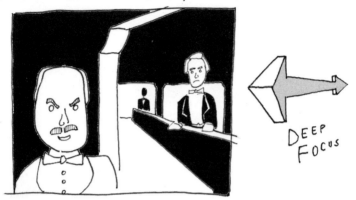

DEEP FOCUS

THERE ARE THREE PRIMARY WAYS TO CONTROL
DEPTH OF FIELD : BY OPENING OR CLOSING
THE LENS' APERTURE, CHANGING THE LENS'
FOCAL LENGTH, OR PHYSICALLY MOVING
THE CAMERA CLOSER TO OR FARTHER
AWAY FROM YOUR SUBJECT.

APERTURE

physical distance

FOCAL LENGTH

to
increase
DEPTH OF FIELD :

Stop down!

MAKE THE APERTURE SMALLER

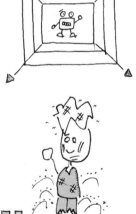

Zoom out !

OR USE A WIDER- ANGLE LENS

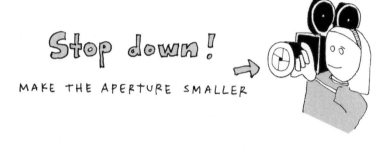

Move away !

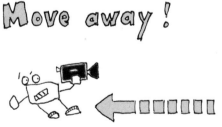

To

decrease

DEPTH OF FIELD :

Open up!

MAKE THE APERTURE WIDER →

Zoom in!

OR USE A LONGER LENS

Move in!

IF YOU WANT TO KNOW EXACTLY HOW MUCH
DEPTH OF FIELD YOU'RE GETTING, IT'S
NECESSARY TO REFER TO A DEPTH OF FIELD
CHART. YOU CAN FIND THESE CHARTS IN

THE AMERICAN CINEMATOGRAPHER MANUAL,
THE PROFESSIONAL CINEMATOGRAPHER'S
BIBLE. YOU CAN ALSO FIND D.O.F.
CALCULATORS ONLINE.

HERE'S A PORTION OF A D.O.F. CHART FOR
A 25mm LENS USED WITH A 16mm
CAMERA. WHAT THE CHART TELLS YOU IS
THE RANGE OF FOCUS YOU GET WHEN
YOU FOCUS YOUR LENS AT A CERTAIN
DISTANCE AND SET THE APERTURE TO
A CERTAIN F-STOP.

Depth of field chart
25mm LENS (16mm camera)

HYPERFOCAL DISTANCE :	28' 10"	20' 2"	14' 5"
f/stop :	f/2.8	f/4	f/5.6
FOCUS DISTANCE (FEET)	NEAR FAR	NEAR FAR	NEAR FAR
10	7' 5" 15' 2"	6' 9" 19' 6"	5' 11" 31' 6"

FOR EXAMPLE, LOOK IN THE COLUMN UNDER
F/4. WHEN YOU FOCUS YOUR LENS AT 10 FEET,

AND SET THE APERTURE TO f/4,
EVERYTHING AT A DISTANCE BETWEEN
6'9" AND 19'6" FROM THE LENS WILL BE
IN FOCUS. STOP DOWN TO f/5.6, AND
NOW THE RANGE OF FOCUS IS FROM
5'11" TO 31'6" !

IN THE TOP ROW OF THE CHART, YOU'LL FIND
THE HYPERFOCAL DISTANCES. WHEN YOU
FOCUS AT THIS DISTANCE, YOU GET THE
GREATEST DEPTH OF FIELD FOR THE GIVEN
F-STOP. IN FACT, YOUR FOCUS EXTENDS
FROM HALF THE HYPERFOCAL DISTANCE TO
INFINITY.

FOR INSTANCE, WHEN OUR 25mm LENS IS SET
TO f/4, ITS HYPERFOCAL DISTANCE IS
20'2". THAT MEANS WHEN WE FOCUS AT
20'2", EVERYTHING FROM 10'1" TO
INFINITY WILL BE IN FOCUS.

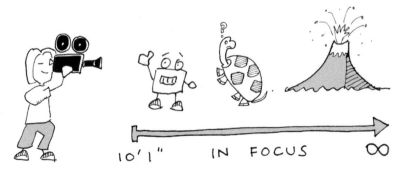

10'1" IN FOCUS ∞

THE HYPERFOCAL DISTANCE IS HANDY
WHEN YOU'RE SHOOTING IN A FAST-PACED
SITUATION AND YOU DON'T WANT TO WORRY
ABOUT ADJUSTING YOUR FOCUS. AS LONG
AS YOUR SUBJECT REMAINS BETWEEN
HALF YOUR HYPERFOCAL DISTANCE AND
INFINITY, YOU'RE GOLDEN!

A WORD ABOUT

depth of field for video!

YOU MAY HAVE NOTICED THAT WHEN YOU'RE
SHOOTING WITH YOUR VIDEO CAMERA,
EVERY<u>THING</u> LOOKS IN FOCUS.

THIS HAS TO DO WITH THE SIZE OF THE
IM<u>AGE</u> SEN<u>SOR</u>, THE "CHIP" IN YOUR VIDEO
CAMERA THAT CONVERTS LIGHT PASSING
THROUGH THE LENS INTO A VIDEO IMAGE.
THE SMALLER THE CHIP, THE MORE DEPTH
OF FIELD -- AND IN CONSUMER VIDEO

CAMERAS, THE CHIP IS PRETTY DANG SMALL.
MOREOVER, THE IMAGE SENSOR IS QUITE
SENSITIVE TO LIGHT, WHICH MEANS
IN MOST LIGHTING SITUATIONS, THE CAMERA'S
IRIS (APERTURE) WILL HAVE TO BE PRETTY
SMALL. AS YOU RECALL, THE SMALLER THE
APERTURE, THE MORE D.O.F. THE BOTTOM LINE:
GETTING SHALLOW DEPTH OF FIELD WITH A
VIDEO CAMERA ISN'T IMPOSSIBLE, BUT IT
CAN BE A CHALLENGE.

SOME tips FOR focusing YOUR LENS

1. FOCUS YOUR VIEWFINDER!

SOME CAMERAS HAVE A DIOPTER, A FOCUS
CONTROL FOR THE VIEWFINDER. BEFORE YOU
SHOOT, IT'S A GOOD IDEA TO FOCUS THE
DIOPTER TO YOUR EYESIGHT. FIRST, POINT
THE CAMERA AT A BLANK WALL AND
THROW THE LENS OUT OF FOCUS. NEXT,
ADJUST THE DIOPTER SO THE STUFF IN
THE VIEWFINDER IS IN FOCUS: SOMETIMES
THERE ARE CROSSHAIRS YOU CAN FOCUS ON;
OTHER TIMES, YOU CAN FOCUS ON THE
GROUND GLASS, THE GRAINY MATERIAL
YOU SEE IN THE VIEWFINDER. THAT'S IT!

2. TURN OFF THE AUTOFOCUS!

MOST VIDEO CAMERAS HAVE AN AUTOFOCUS
OPTION. DON'T USE IT! NOTHING SAYS
"AMATEURISH VIDEO" LIKE A SHOT WHERE
THE AUTOFOCUS KEEPS SHIFTING. BETTER
TO SET THE FOCUS TO MANUAL AND USE
THE "ZOOM AND FOCUS" TECHNIQUE.

3. ZOOM AND FOCUS!

WHEN YOU'RE FOCUSING ON YOUR SUBJECT
WITH A ZOOM LENS, ZOOM IN ALL THE
WAY, SET YOUR FOCUS, THEN ZOOM OUT
TO YOUR DESIRED FOCAL LENGTH.
YOUR SUBJECT WILL BE NICE AND SHARP.

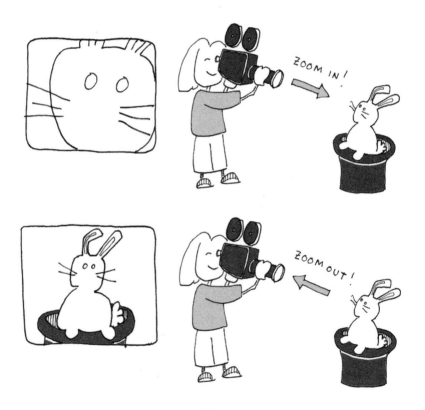

← HA.

brain tickler 3.

ACROSS

1. SEE 11 ACROSS.

3. A _____ LENS LETS YOU ADJUST THE FOCAL LENGTH OVER A GIVEN RANGE.

5. ZOOM IN, GET CLOSER, OR OPEN UP THE APERTURE TO _____ ZONE OF FOCUS.

7. FOCAL LENGTH DETERMINES HOW _____ YOUR SUBJECT APPEARS IN THE LENS.

9. NUMBER THAT DESCRIBES SIZE OF THE APERTURE OF THE LENS.

11. THE ZONE OF ACCEPTABLE FOCUS AROUND YOUR SUBJECT (SEE 1 ACROSS, 2 DOWN).

DOWN

2. SEE 11 ACROSS.

4. A FAST LENS LETS _____ LIGHT PASS THROUGH THAN A SLOWER LENS.

6. THE "PUPIL" OF THE LENS.

8. A LENS BENDS (OR _____) LIGHT.

10. LENS WITH A FIXED FOCAL LENGTH.

61

exposing film

THE HUMAN EYE IS AN AMAZING THING. IT CAN
ADJUST TO A WIDE RANGE OF LIGHTING
SITUATIONS, FROM VERY DIM TO VERY
BRIGHT. FILM, ALAS, ISN'T THAT FLEXIBLE.
IF YOU EXPOSE IT TO TOO MUCH LIGHT, IT
WILL GET OVEREXPOSED; TOO LITTLE LIGHT,
UNDEREXPOSED. THIS RANGE OF EXPOSURE IS
KNOWN AS A FILM'S LATITUDE.

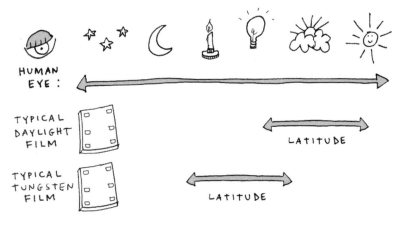

HUMAN
EYE:

TYPICAL
DAYLIGHT
FILM LATITUDE

TYPICAL
TUNGSTEN
FILM LATITUDE

THE CHALLENGE TO EXPOSING YOUR FILM
WELL IS REPRODUCING THE SCENE YOU'RE
SHOOTING AS FAITHFULLY AS POSSIBLE
WHILE WORKING WITHIN THE LIMITS OF
YOUR FILM'S LATITUDE.

THE FIRST STEP TO PROPERLY EXPOSING YOUR
FILM IS TO TAKE A LIGHT METER READING.
A LIGHT METER MEASURES THE BRIGHTNESS
OF THE LIGHT AND SPITS OUT AN F-STOP
NUMBER. ONCE YOU SET YOUR LENS
TO THIS F-STOP, YOU'RE GOOD TO GO.

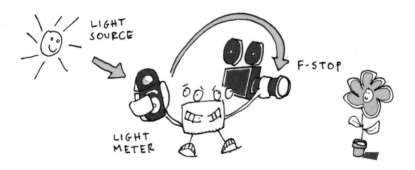

BEFORE YOU TAKE A METER READING, YOU
USUALLY HAVE TO TELL YOUR LIGHT METER
A COUPLE THINGS. FIRST, WHAT IS THE
SPEED OF THE FILM YOU'RE SHOOTING? AS
YOU RECALL, ALL FILMS HAVE AN EXPOSURE

INDEX (EI) RATING. THE HIGHER THE EI,
THE MORE SENSITIVE YOUR FILM IS TO LIGHT.
SECOND, WHAT IS YOUR CAMERA'S SHUTTER
SPEED, I.E. HOW MUCH TIME DOES THE SHUTTER
STAY OPEN, EXPOSING EACH FRAME OF FILM?

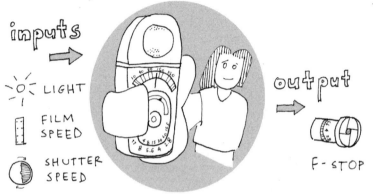

inputs

LIGHT

FILM
SPEED

SHUTTER
SPEED

output

F-STOP

THERE ARE TWO TYPES OF LIGHT METERS,
REFLECTED AND INCIDENT. A REFLECTED
METER MEASURES THE LIGHT BOUNCING
OFF YOUR SUBJECT AND CALCULATES AN
EXPOSURE THAT'S IN THE MIDDLE OF THE
EXPOSURE RANGE. THIS EXPOSURE IS
REFERRED TO AS "MIDDLE GRAY." BECAUSE A
REFLECTED METER MEASURES REFLECTED
LIGHT, IT'S IMPORTANT TO KNOW THAT
SOME SURFACES REFLECT MORE LIGHT
THAN OTHERS. FOR EXAMPLE, SAY YOU'RE
TAKING A REFLECTED METER READING OF A

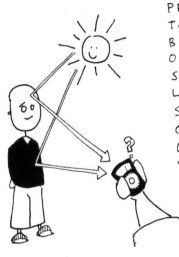

PERSON WITH A PALE SKIN TONE WHO IS WEARING A BLACK SWEATER. OBVIOUSLY, THE PERSON'S SKIN WILL REFLECT MORE LIGHT THAN THE SWEATER, SO DEPENDING ON WHICH REFLECTED LIGHT YOU MEASURE, YOU GET TWO ENTIRELY DIFFERENT METER READINGS.

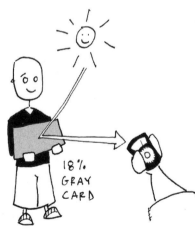

18%
GRAY
CARD

THE SOLUTION IS TO ASK YOUR SUBJECT TO HOLD AN 18% GRAY CARD, WHICH IS JUST A PIECE OF GRAY CARDBOARD THAT REFLECTS 18% OF THE LIGHT THAT HITS IT. THE CARD THUS PROVIDES A "MIDDLE GRAY" THAT YOUR LIGHT METER CAN READ, ENSURING THAT THE ENTIRE SCENE IS PROPERLY EXPOSED.

THE OTHER TYPE OF LIGHT METER, AN INCIDENT
METER, MEASURES THE LIGHT FALLING ON
(RATHER THAN REFLECTED FROM) A SUBJECT.
AN INCIDENT METER HAS A HEMISPHERICAL
DOME THAT ACCEPTS THE LIGHT AND ACTS
AS AN 18% GRAY CARD. TO TAKE A READING,
AN INCIDENT METER SHOULD BE IN THE SAME
LIGHT AS THE SUBJECT, WITH THE DOME FACING
THE CAMERA. TO REMEMBER THIS, YOU MIGHT
THINK OF THE METER AS A LITTLE VOODOO
DOLL OF YOUR SUBJECT!

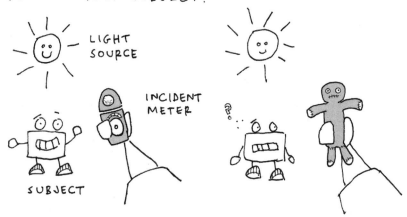

AS WE SAID, THE CHALLENGING THING ABOUT
EXPOSING FILM IS HOW TO "FIT" THE RANGE
OF LIGHT IN THE SCENE YOU'RE FILMING
INTO THE LIMITED EXPOSURE RANGE OF THE
FILM. THIS CAN BE ESPECIALLY TRICKY IN
HIGH CONTRAST LIGHTING SITUATIONS.

FOR INSTANCE, SAY YOU'RE SHOOTING TWO
SUBJECTS, ONE STANDING IN BRIGHT
SUNLIGHT, THE OTHER STANDING UNDER A
SHADE TREE. YOU WANT BOTH SUBJECTS
TO BE PROPERLY EXPOSED.

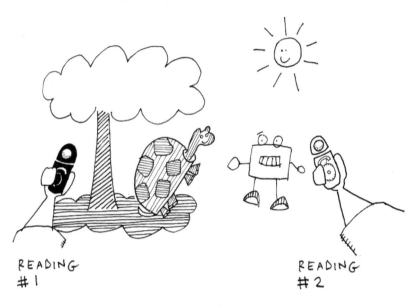

READING
#1

READING
#2

FIRST, YOU TRY TAKING AN INCIDENT METER
READING FOR THE TURTLE IN THE SHADE. THE
TURTLE AND THE SHADED PARTS OF THE
SCENE COME OUT PROPERLY EXPOSED, BUT
THE BRIGHTLY LIT ROBOT IS WAY
OVEREXPOSED...

READING #1

NEXT, YOU TAKE A READING OF THE ROBOT IN THE SUN. NOW THE ROBOT AND THE SUNNY PARTS OF THE TREE ARE PROPERLY EXPOSED, BUT THE TURTLE IS WAY UNDEREXPOSED...

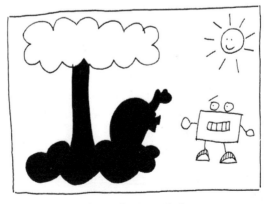

READING #2

WHAT TO DO? YOU CAN TRY "SPLITTING THE DIFFERENCE," THAT IS, CHOOSING AN F-STOP SOMEWHERE BETWEEN THE SHADY AND SUNNY EXPOSURES. THE TURTLE WILL BE A BIT UNDEREXPOSED AND THE ROBOT A BIT OVEREXPOSED, BUT IF YOUR FILM HAS ENOUGH LATITUDE, YOU MAY PULL OFF AN EXPOSURE YOU CAN LIVE WITH. YOU COULD ALSO USE A REFLECTOR, A BIG PIECE OF WHITE CARDBOARD, TO BRIGHTEN UP TURTLE. OR YOU COULD CHANGE THE SCENE, ASKING TURTLE TO STEP INTO THE SUNLIGHT, OR ROBOT INTO THE SHADE. THE BOTTOM LINE: WHEN THE RANGE OF BRIGHTNESS IN A SCENE EXCEEDS YOUR FILM'S LATITUDE, EXPOSURE CAN BE TRICKY.

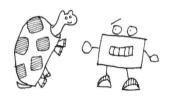

the 4 speeds !

BY NOW, YOU'VE PROBABLY NOTICED THAT
THERE ARE A LOT OF VARIABLES INVOLVED IN
CONTROLLING EXPOSURE. A GOOD WAY TO KEEP
THINGS STRAIGHT IS TO THINK OF EXPOSURE
IN TERMS OF "4 SPEEDS":

1. film speed
2. shutter speed
3. camera speed
4. lens speed ☆

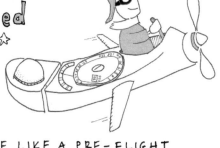

THESE "SPEEDS" ARE LIKE A PRE-FLIGHT
CHECKLIST YOU SHOULD RUN THROUGH BEFORE
YOU SHOOT. ALL THESE SPEEDS CAN AFFECT
YOUR EXPOSURE.

☆YEAH, YOU'RE RIGHT. TECHNICALLY, LENS SPEED IS
THE WIDEST APERTURE A GIVEN LENS CAN OPEN TO.
BUT FOR THE PURPOSES OF OUR "4 SPEEDS" FORMULA,
LET'S SAY IT REFERS TO F-STOP SETTINGS IN GENERAL.

FILMMAKERS LIKE TO TALK ABOUT EXPOSURE IN TERMS OF <u>STOPS</u>. WHENEVER THE AMOUNT OF EXPOSURE DOUBLES OR HALVES, IT'S SAID TO CHANGE BY A STOP.

I SWITCHED FROM A FILM WITH A SPEED OF ISO 100 TO A FILM WITH A SPEED OF ISO 200.

YOU GAINED A STOP OF EXPOSURE. >

I CHANGED MY SHUTTER SPEED FROM $\frac{1}{24}$ SEC. TO $\frac{1}{48}$ SEC.

YOU LOST A STOP OF EXPOSURE. >

I OPENED MY APERTURE FROM f/8 to f/4.

YOU GAINED TWO STOPS OF EXPOSURE. >

I CHANGED MY CAMERA SPEED FROM 24 FPS TO 48 FPS.

YOU LOST A STOP OF EXPOSURE.

WHEN YOU INCREASE THE CAMERA SPEED, YOU DECREASE THE EXPOSURE ?! WHAT GIVES ?!

"WHAT GIVES" IS THE SHUTTER SPEED EQUATION. REMEMBER, SHUTTER SPEED DEPENDS ON TWO THINGS : THE ANGLE OF THE SHUTTER AND THE CAMERA SPEED ...

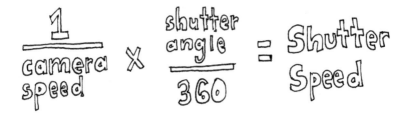

$$\frac{1}{camera\ speed} \times \frac{shutter\ angle}{360} = Shutter\ Speed$$

SO, LET'S SAY YOU'VE GOT A 180° SHUTTER. WHEN YOU RUN YOUR CAMERA AT 24 FPS, YOUR SHUTTER SPEED IS $\frac{1}{48}$ SEC. DOUBLE THE

CAMERA SPEED TO 48 FPS, AND NOW YOUR
SHUTTER SPEED IS $\frac{1}{96}$ SEC., I.E. H<u>ALF</u> AS LONG.
YOU LOSE A STOP OF EXPOSURE.

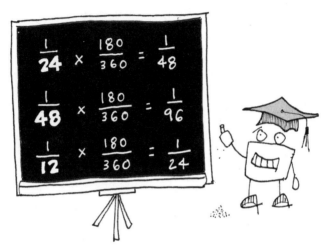

$$\frac{1}{24} \times \frac{180}{360} = \frac{1}{48}$$

$$\frac{1}{48} \times \frac{180}{360} = \frac{1}{96}$$

$$\frac{1}{12} \times \frac{180}{360} = \frac{1}{24}$$

H<u>ALVE</u> THE CAMERA SPEED TO 12 FPS, AND
NOW YOU'VE <u>DOUBLED</u> YOUR SHUTTER SPEED
TO $\frac{1}{24}$ SEC. YOU GAIN A STOP.

KEEP IN MIND THAT ALL 4 OF THESE
SPEEDS WORK TOGETHER. FOR EXAMPLE,
SAY YOU'RE SHOOTING FILM...
WITH A SPEED OF ISO 50
AT A CAMERA SPEED OF 24 FPS
WITH A SHUTTER SPEED OF $\frac{1}{48}$ SEC.

IN A GIVEN LIGHTING SITUATION, YOUR
LIGHT METER TELLS YOU TO SET YOUR
F-STOP TO $\boxed{f/2.8}$. SUDDENLY, YOUR
CAMERA OPERATOR TELLS YOU...

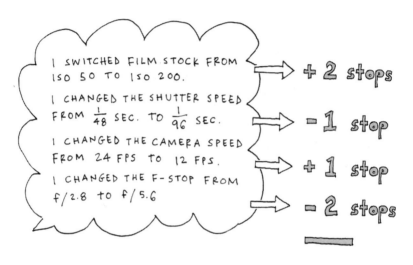

I SWITCHED FILM STOCK FROM
ISO 50 TO ISO 200. → + 2 stops

I CHANGED THE SHUTTER SPEED
FROM $\frac{1}{48}$ SEC. TO $\frac{1}{96}$ SEC. → - 1 stop

I CHANGED THE CAMERA SPEED
FROM 24 FPS TO 12 FPS. → + 1 stop

I CHANGED THE F-STOP FROM
$f/2.8$ TO $f/5.6$ → - 2 stops

net change ◎

SO WHAT HAPPENED?! WILL YOUR SHOT
BE OVEREXPOSED?! UNDEREXPOSED?!
IF YOU DO THE MATH, IT TURNS OUT
ALL THESE TWEAKS CHANGED THE
EXPOSURE BY... NO STOPS. SO, CHILL OUT!

brain tickler 4.

ACROSS

2. PRINCIPAL OUTPUT OF A LIGHT METER.

4. WHEN YOU DOUBLE YOUR CAMERA SPEED, YOU _____ THE AMOUNT OF LIGHT THAT REACHES THE FILM.

5. TERM THAT DESCRIBES HOW "FORGIVING" A FILM STOCK IS TO OVER AND UNDER EXPOSURE.

6. LIGHT METER THAT MEASURES LIGHT FALLING ON A SUBJECT.

7. OPEN YOUR LENS APERTURE BY ONE STOP TO _____ THE AMOUNT OF LIGHT THAT REACHES YOUR FILM.

DOWN

1. WHEN YOU SWITCH FROM 100 TO 200 SPEED FILM, YOU _____ THE SENSITIVITY OF YOUR FILM.

3. LIGHT METER THAT MEASURES LIGHT BOUNCING OFF YOUR SUBJECT.

 # the video camera

FILM CAMERAS AND VIDEO CAMERAS HAVE A LOT
IN COMMON. BOTH HAVE LENSES WHICH
CAPTURE AND FOCUS LIGHT. BOTH HAVE A
LIGHT SENSITIVE ELEMENT (MOVIE FILM
IN A FILM CAMERA; THE IMAGE SENSOR OR
"CHIP" IN A VIDEO CAMERA). BOTH
TRANSLATE FLUID MOTION INTO A SERIES
OF STILL IMAGES. BUT IT'S ALSO
IMPORTANT TO REMEMBER THAT FILM AND
VIDEO AREN'T THE SAME THING.
UNDERSTANDING THE UNIQUE QUALITIES OF
EACH MEDIUM WILL HELP YOU MAKE
BETTER FILMS AND BETTER VIDEOS.

FILMMAKING IS A PHOTO-CHEMICAL
PROCESS: FILM IS EXPOSED TO LIGHT
THEN SOAKED IN VARIOUS CHEMICALS
TILL AN IMAGE APPEARS.

VIDEO MAKING, ON THE OTHER HAND, IS A
PHOTO-ELECTRICAL PROCESS. WHAT'S
THAT MEAN? WELL, LET'S LOOK AT HOW
A VIDEO CAMERA WORKS:

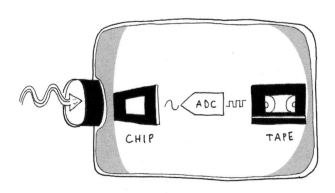

CHIP

TAPE

AS WITH A FILM CAMERA, LIGHT ENTERS
THE LENS OF A VIDEO CAMERA AND IS
FOCUSED ON THE IMAGE PLANE. BUT UNLIKE
A FILM CAMERA, THERE'S NO FILM THERE.
INSTEAD, THERE'S AN ELECTRONIC DEVICE
CALLED AN IMAGE SENSOR OR "CHIP." THE
CHIP CONVERTS LIGHT INTO AN ELECTRICAL
CURRENT, OR VIDEO SIGNAL.

IN OLD ANALOG VIDEO CAMERAS, THIS SIGNAL
WOULD BE RECORDED RIGHT ONTO VIDEO TAPE.
IN DIGITAL VIDEO CAMERAS, THOUGH, THE
VIDEO SIGNAL IS SENT THROUGH AN ANALOG-
TO DIGITAL CONVERTER (ADC) WHERE IT
IS CONVERTED INTO DIGITAL INFORMATION
THAT CAN BE RECORDED ONTO A VIDEO TAPE,
MEMORY CARD OR HARD DRIVE.

THE CHIP

SENSOR CHIPS COME IN TWO FLAVORS :
CCD (CHARGE-COUPLED DEVICE) AND
CMOS (COMPLEMENTARY METAL-OXIDE-
SEMICONDUCTOR).

BOTH WORK IN ROUGHLY THE SAME WAY,
CONVERTING LIGHT INTO ELECTRICAL
CURRENT BY WAY OF A GRID OF LITTLE
LIGHT-SENSITIVE DIODES CALLED
PIXELS (SHORT FOR "PICTURE ELEMENTS").

FILM GRAINS

PIXELS

IF FILM GRAINS ARE THE BUILDING
BLOCKS OF THE FILM IMAGE, PIXELS
ARE THE BUILDING BLOCKS OF THE
VIDEO IMAGE.

THE PIXELS ON THE SENSOR CHIP
CONVERT LIGHT INTO AN ELECTRICAL
CHARGE : THE BRIGHTER THE LIGHT,

THE GREATER THE CHARGE; LESS LIGHT, LESS CHARGE.

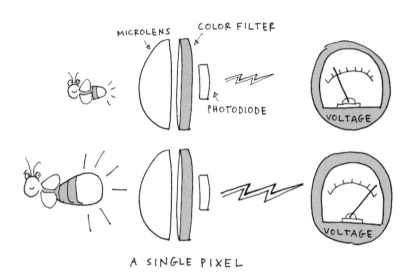

A SINGLE PIXEL

PIXELS RESPOND ONLY TO THE INTENSITY OF LIGHT, SO HOW DO THEY KNOW WHAT COLOR IT IS? FANCY HIGH-END CAMERAS ACTUALLY HAVE THREE CHIPS. A BEAM SPLITTER SPLITS THE IMAGE FORMED BY THE LENS INTO A RED, GREEN, AND BLUE VERSION, ONE VERSION FOR EACH CHIP.

THE CAMERA THEN COMBINES THESE
THREE VIDEO SIGNALS TOGETHER TO
MAKE A COLOR IMAGE.

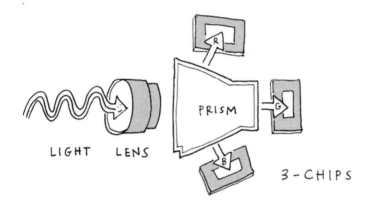

LIGHT LENS

PRISM

R

G

B

3 - CHIPS

IN ONE - CHIP CAMERAS, EACH OF THE
PIXELS ON THE CHIP HAS A LITTLE
COLOR FILTER, EITHER RED, GREEN,
OR BLUE.

1 - CHIP

AS A RULE, ONE - CHIP CAMERAS PRODUCE
LOWER QUALITY IMAGES THAN 3 - CHIP
CAMERAS — THOUGH THERE ARE SOME

FANCY, PRICEY ONE-CHIPPERS OUT THERE.

< REMEMBER — A COLOR VIDEO
 IMAGE IS MADE
 FROM DIFFERENT
 COMBINATIONS
 OF RED,
 GREEN,
 AND
 BLUE !!

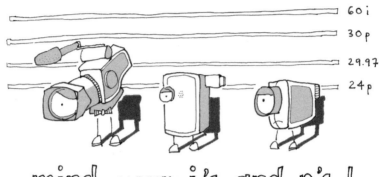

60 i

30 p

29.97

24 p

mind your i's and p's !

CHOOSING A VIDEO CAMERA USED TO BE
EASY. IF YOU LIVED IN THE U.S., THE
CAMERA WOULD SHOOT INTERLACED
VIDEO AT (ABOUT) 30 FRAMES
PER SECOND. NOWADAYS,
THERE'S A VERITABLE
ROGUES GALLERY OF
VIDEO CAMERAS WITH
VARIOUS FRAME RATES, SCANNING METHODS,
AND PIXEL COUNTS.

frame rate

UNTIL PRETTY RECENTLY, SHOOTING VIDEO IN
THE U.S. MEANT SHOOTING AT 30 FRAMES
PER SECOND (THE ACTUAL FRAME RATE IS
29.97 FRAMES PER SECOND, FOR REASONS
THAT ONLY A TELEVISION ENGINEER

COULD LOVE). BUT WHY THAT FRAME RATE?
THE NORMAL FRAME RATE FOR FILM IS
24 FPS, AFTER ALL. IN THE EARLY YEARS
OF VIDEO, T.V. ENGINEERS LINKED VIDEO
FRAME RATE TO THE FREQUENCY OF THE
ALTERNATING CURRENT GENERATED BY THE
ELECTRIC COMPANY. IN THE U.S., POWER
GENERATORS SPIN AROUND 60 TIMES A
SECOND, I.E. 60 HERTZ.

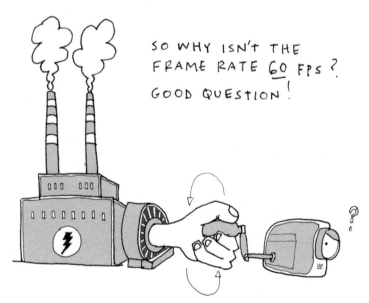

SO WHY ISN'T THE
FRAME RATE 60 FPS?
GOOD QUESTION!

IT TURNS OUT THAT EACH FRAME OF VIDEO
IS ACTUALLY MADE UP OF TWO HALF FRAMES
CALLED FIELDS. SO YOU CAN THINK OF THE

ELECTRICAL GENERATOR AT THE POWER PLANT
LIKE A BIG HAND THAT CRANKS THE VIDEO
THROUGH YOUR CAMERA AT 60 FIELDS
(I.E. 30 FRAMES) PER SECOND.

THESE DAYS, THERE ARE FINALLY VIDEO
CAMERAS ON THE MARKET THAT HAVE A
FRAME RATE OF 24 FPS. WHY? FOR
THAT COVETED "FILM LOOK," OF COURSE!

interlace vs. progressive

WHEN YOU SHOOT WITH A FILM CAMERA AT
24 FRAMES PER SECOND, 24 FRAMES OF
FILM ARE EXPOSED EACH SECOND. WHEN
YOU SHOOT WITH A VIDEO CAMERA AT 30
FRAMES PER SECOND, 30 FRAMES OF VIDEO
ARE ALSO EXPOSED EACH SECOND, RIGHT?
UP UNTIL RECENTLY, THE ANSWER TO THAT
QUESTION HAS BEEN "NOT EXACTLY."
INSTEAD, A FRAME OF VIDEO IS COMPOSED
OF TWO HALF FRAMES CALLED FIELDS
THROUGH A PROCESS CALLED INTERLACE
SCANNING. PHILO FARNSWORTH, THE GUY
WHO INVENTED THE FIRST TOTALLY

ELECTRONIC T.V. CAME UP WITH THE IDEA
TO CREATE A VIDEO IMAGE OUT OF A
SERIES OF SCAN LINES. THE NOTION
STRUCK HIM WHILE HE WAS PLOWING A
FIELD ON HIS FAMILY'S FARM IN IDAHO
BACK IN THE EARLY 1900's. SUPPOSEDLY.

A VIDEO CAMERA THAT USES INTERLACE
SCANNING FIRST RECORDS ALL THE ODD-
NUMBERED SCAN LINES OF THE VIDEO
IMAGE. THIS IS THE FIRST FIELD. THEN
IT RECORDS ALL THE EVEN-NUMBERED
SCAN LINES. THIS IS THE SECOND FIELD.
THE TWO FIELDS MERGE TO FORM A

SINGLE FRAME OF VIDEO.

FIRST FIELD · SECOND FIELD · FRAME

BUT WHY GO TO THE TROUBLE OF SPLITTING
FRAMES INTO FIELDS? WELL, FOR ONE THING,
IT PREVENTS FLICKER. SINCE FIELDS REFRESH
60 TIMES PER SECOND, THIS IS FAST ENOUGH
FOR THE VIDEO IMAGE TO APPEAR SMOOTH
AND CONTINUOUS.

BUT MORE FUNDAMENTALLY, IT'S FOR THE
SAME REASON YOU COMPRESS FILES THAT
YOU ATTACH TO EMAIL, OR COMPRESS

VIDEOS YOU STREAM ON THE INTERNET: BECAUSE IT'S EASIER TO TRANSMIT LESS DATA THAN MORE DATA. EARLY T.V. ENGINEERS REALIZED IT WAS EASIER TO TRANSMIT 60 HALF FRAMES OF VIDEO EVERY SECOND THAN 30 FULL FRAMES.

INTERLACE MAY BE AN ELEGANT SOLUTION TO THE PROBLEM OF MAKING VIDEO, BUT IT AIN'T PERFECT. IN FACT, IT CAN CREATE ALL SORTS OF GLITCHES AND ARTIFACTS. A BETTER ALTERNATIVE THAT IS INCREASINGLY COMMON IS PROGRESSIVE SCANNING. PROGRESSIVE DOESN'T USE FIELDS. INSTEAD, IT MAKES MOVING IMAGES THE OLD FASHIONED WAY: ONE WHOLE IMAGE AT A TIME. WHEN YOU SHOOT A VIDEO CAMERA WITH PROGRESSIVE SCANNING AT 30 FRAMES PER SECOND, 30 FULL FRAMES OF VIDEO ARE SCANNED EACH SECOND.

standard vs. high definition

WHAT DISTINGUISHES STANDARD DEFINITION (SD)
VIDEO FROM HIGH DEFINITION (HD) VIDEO
IS THE NUMBER OF PIXELS THAT MAKE UP
THE IMAGE. REMEMBER, A FRAME OF VIDEO
CONSISTS OF HORIZONTAL ROWS OF PIXELS
CALLED SCAN LINES. THE MORE SCAN LINES,
THE HIGHER THE RESOLUTION OF THE IMAGE.
IN THE U.S., STANDARD DEF HAS 480 SCAN
LINES. HIGH DEF, ON THE OTHER HAND, HAS
EITHER 720 OR 1080 SCAN LINES.

THE OTHER DIFFERENCE BETWEEN SD AND
HD VIDEO IS THE SHAPE OF THE FRAME.
THE RATIO OF THE FRAME'S WIDTH TO ITS
HEIGHT IS CALLED THE FRAME'S ASPECT
RATIO.

3

4

9

16

standard definition high definition

88

SD HAS AN ASPECT RATIO OF 4:3 (THE
EQUIVALENT OF THE 1.33:1 ASPECT RATIO OF
16MM FILM). HD HAS A WIDER-SCREEN
ASPECT RATIO OF 16:9.

ONE NICE THING ABOUT SHOOTING FILM IS
THAT NO MATTER WHAT FORMAT OR
CAMERA YOU USE, THE NORMAL FRAME
RATE IS 24 FPS. ONE NICE THING ABOUT
SHOOTING VIDEO IS YOU HAVE A HUGE
SELECTION OF FRAME RATES AND
FORMATS. TROUBLE IS, ALL THESE CHOICES
CAN BE PRETTY CONFUSING. MY ADVICE?
TAKE A BUNCH OF VIDEO CAMERAS FOR
A TEST DRIVE AND DECIDE WHICH ONE
MAKES IMAGES YOU LIKE.

BUT REMEMBER, JUST BECAUSE YOU SHOOT WITH A
GOOD CAMERA DOESN'T MEAN YOU'LL MAKE A
GOOD VIDEO. YOUR IDEAS AND YOUR TECHNIQUE
ARE <u>WAY</u> MORE IMPORTANT THAN YOUR GEAR.

 5.

ACROSS

3. ELEMENT OF VIDEO CAMERA THAT CONVERTS LIGHT INTO AN ELECTRICAL CURRENT.

6. VIDEO IS A PHOTO—_____ IMAGE MAKING PROCESS.

7. IT'S HIGHER QUALITY THAN "SD."

DOWN

1. LITTLE "GRAINS" THE VIDEO IMAGE IS COMPOSED OF.

2. SEE 4 DOWN.

4. A VIDEO IMAGE IS MADE UP OF A SERIES OF HORIZONTAL _____ . (SEE 2 DOWN)

5. A SINGLE FRAME OF INTERLACE VIDEO IS COMPOSED OF TWO _____ .

exposing video

AS WITH FILM, EXPOSING VIDEO IS PART ART AND PART SCIENCE. BUT WHILE EXPOSING FILM IS A "MANUAL" PROCESS (I.E., YOU TAKE METER READINGS AND MANUALLY SET YOUR F-STOP, CAMERA SPEED, ETC.), VIDEO CAMERAS ARE DESIGNED TO MAKE MANY OF THE EXPOSURE DECISIONS FOR YOU, AUTOMATICALLY. IN FACT, MOST VIDEO CAMERAS HAVE AN AUTO EXPOSURE (AE) OPTION. TOGETHER WITH AUTO FOCUS, THIS ALLOWS YOU TO "POINT AND SHOOT" WHILE THE CAMERA FIGURES OUT THE FOCUS AND EXPOSURE.

THE ADVANTAGE OF THESE AUTOMATIC FUNCTIONS IS THEY LEAVE YOU WITH FEWER THINGS TO WORRY ABOUT WHILE YOU'RE SHOOTING. IN A HECTIC, FAST-PACED SHOOTING SITUATION, THIS CAN BE REALLY HELPFUL. BUT BEWARE! THE MORE

AUTO FUNCTIONS YOU USE, THE LESS
CONTROL YOU HAVE OVER THE IMAGE
YOU'RE MAKING.

AS A RULE, YOU'LL GET BETTER RESULTS IF
YOU EXPOSE VIDEO THE WAY YOU EXPOSE
FILM : MANUALLY.

white balance

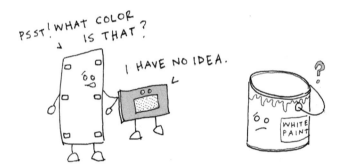

JUST LIKE COLOR MOVIE FILM, VIDEO
NEEDS TO BE BALANCED FOR THE KIND
OF LIGHT YOU'RE SHOOTING IN. PUT
ANOTHER WAY : FOR A GIVEN TYPE OF
LIGHT, YOU HAVE TO TELL YOUR VIDEO
CAMERA WHAT COLOR WHITE IS. THIS
IS CALLED WHITE BALANCING. THOUGH

MOST VIDEO CAMERAS WILL DO THIS
AUTOMATICALLY, IT'S USUALLY A GOOD
IDEA TO SET THE WHITE BALANCE
MANUALLY. JUST POINT THE CAMERA AT
A SMOOTH WHITE SURFACE AND HIT THE
WHITE BALANCE BUTTON. ONCE WHITE IS
SET, ALL THE COLORS IN THE SCENE WILL
BE ACCURATELY RENDERED.

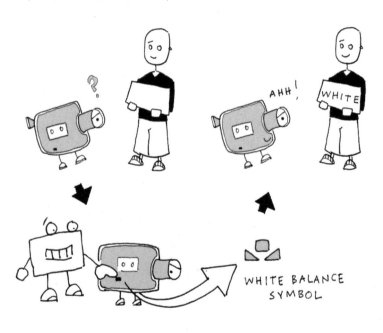

BE SURE TO SET YOUR WHITE BALANCE
ANY TIME THE LIGHTING SITUATION

CHANGES (E.G., WHEN YOU MOVE FROM INDOOR LIGHT TO OUTDOOR LIGHT, ETC.).

tip from the hippy

HEY MAN, FOR A FAR OUT EFFECT, TRY WHITE BALANCING ON A COLORED SURFACE. IT'LL THROW ALL THE COLORS IN THE SCENE OUT OF WHACK. IT'S TOTALLY TRIPPY!

iris, shutter, and gain

THE THREE PRIMARY WAYS TO CONTROL YOUR VIDEO EXPOSURE ARE WITH THE IRIS, THE SHUTTER, AND THE GAIN. IN MOST NORMAL SHOOTING SITUATIONS, ALL YOU'LL USUALLY NEED TO ADJUST IS THE IRIS.

ON SOME HIGH-END VIDEO CAMERAS, THE IRIS IS THE SAME KIND OF MECHANICAL DEVICE YOU FIND INSIDE THE LENS OF A FILM CAMERA. WHEN YOU OPEN THE IRIS, MORE LIGHT PASSES THROUGH THE LENS; WHEN YOU CLOSE IT, LESS LIGHT PASSES THROUGH. ON LESS FANCY VIDEO CAMERAS, THE IRIS IS AN ELECTRONIC

CIRCUIT, A SORT OF "BRIGHTNESS CONTROL" THAT BRIGHTENS OR DARKENS THE IMAGE.

SO, WHAT'S THE RIGHT EXPOSURE? MOST VIDEO MAKERS EYEBALL IT, ADJUSTING THE IRIS TILL THE IMAGE IN THE VIEW-FINDER LOOKS PROPERLY EXPOSED. IF YOUR CAMERA HAS A ZEBRA STRIPES FUNCTION, THIS CAN BE A BIG HELP. AS THE NAME IMPLIES, ZEBRA STRIPES ARE SHIMMERING LINES THAT APPEAR IN THE VIEWFINDER ON THOSE PARTS OF THE IMAGE THAT ARE OVEREXPOSED.

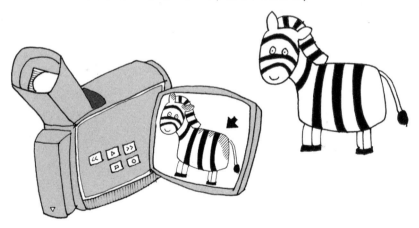

AS YOU ADJUST THE IRIS, THE STRIPES

DISAPPEAR, THUS ASSURING THAT NO PART OF YOUR IMAGE IS CLIPPING, THAT IS, EXCEEDING YOUR CAMERA'S EXPOSURE RANGE.

MOST VIDEO CAMERAS ALLOW YOU TO ADJUST THE SHUTTER SPEED. THIS MAY SEEM A LITTLE ODD SINCE VIDEO CAMERAS DON'T ACTUALLY HAVE A MECHANICAL SHUTTER. WHAT THEY'VE GOT INSTEAD ARE ELECTRONICS THAT CONTROL HOW LONG THE IMAGE SENSOR IS EXPOSED TO LIGHT. A VIDEO CAMERA'S "NORMAL" SHUTTER SPEED IS $\frac{1}{60}$ SECOND. AS YOU INCREASE THE SHUTTER SPEED, YOU DECREASE THE AMOUNT OF TIME THE VIDEO CHIP IS EXPOSED TO LIGHT AND YOU THUS DARKEN THE IMAGE. DECREASE THE SHUTTER SPEED AND YOU LIGHTEN THE IMAGE.

IT'S IMPORTANT TO KEEP IN MIND THAT WHEN YOU ADJUST THE SHUTTER SPEED, YOU NOT ONLY CHANGE YOUR EXPOSURE, YOU ALSO CHANGE THE "LOOK" OF THE VIDEO IMAGE. AT LOWER SHUTTER SPEEDS

SUBJECTS IN MOTION APPEAR TO BLUR. THIS IS PARTICULARLY NOTICEABLE AT SHUTTER SPEEDS BELOW $\frac{1}{60}$ SECOND.

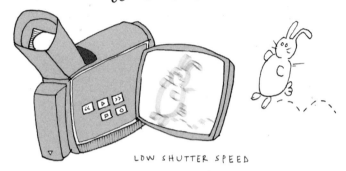

LOW SHUTTER SPEED

AT HIGHER SHUTTER SPEEDS, EACH FRAME OF VIDEO IS SHARP. THE RESULT CAN BE A CHOPPY STROBING EFFECT THAT YOU MAY OR MAY NOT WANT. IF IN DOUBT, TRY A FEW SHUTTER SPEED SETTINGS AND SEE WHAT YOU LIKE BEST.

SOME VIDEO CAMERAS HAVE A GAIN SETTING. THE GAIN ALLOWS YOU TO INCREASE OR DECREASE THE BRIGHTNESS OF THE VIDEO IMAGE BY AMPLIFYING OR REDUCING THE VIDEO SIGNAL. ONLY USE THE GAIN AS A LAST RESORT SINCE IT CAN ADD UNWANTED GRAININESS ("NOISE") TO YOUR IMAGE. ORDINARILY, KEEP THE GAIN SWITCH SET TO ZERO.

film vs. video

IN THIS CORNER, WEIGHING IN AT 24 FPS, THE PHOTO-CHEMICAL WUNDERKIND, THE SPROCKETED SUPERSTAR — FI<u>LM</u>!

AND IN THIS CORNER, WEIGHING IN AT A MARVELOUS VARIETY OF FRAME RATES, A PHOTO-ELECTRIC PHENOM, THE TORNADO OF TIME CODE — VI<u>DEO</u>!

THERE ARE LOTS OF REASONS TO CHOOSE FILM INSTEAD OF VIDEO, OR VIDEO INSTEAD OF FILM: THE SIZE OF YOUR BUDGET, FOR INSTANCE, OR THE KIND OF VENUES WHERE YOU PLAN TO SCREEN YOUR WORK. PERHAPS THE MOST IMPORTANT REASON IS THE <u>LOOK</u> YOU'RE GOING FOR. AS YOU'VE DISCOVERED, FILM AND VIDEO CREATE IMAGES IN SOME

FUNDAMENTALLY DIFFERENT WAYS. AS A RESULT, THERE ARE SOME WAYS IN WHICH THEY LOOK FUNDAMENTALLY DIFFERENT.

grain vs. pixels

THE FILM IMAGE IS COMPOSED OF RANDOMLY DISTRIBUTED GRAINS OF SILVER WHILE THE VIDEO IMAGE IS MADE UP OF A GRID OF SQUARE OR RECTANGULAR PIXELS. THOUGH WE ARE OFTEN BARELY AWARE OF THESE TINY BUILDING BLOCKS OF THE IMAGE, THEY HELP DEFINE THE LOOK OF BOTH MEDIA.

color reproduction

IT USED TO BE POSSIBLE TO SAY THAT FILM REPRODUCES COLOR MUCH BETTER THAN VIDEO. IF YOU'RE COMPARING FILM TO CHEAP ONE-CHIP VIDEO, YOU CAN STILL SAY THAT. BUT NOW IT'S FAIRER TO SAY THAT FILM AND VIDEO CAN BOTH REPRODUCE COLOR BEAUTIFULLY BUT IN THEIR OWN WAY. FILM USES COLOR DYES. THE RESULT CAN BE COLORS THAT ARE WARMER, EVEN PAINTERLY. VIDEO REPRODUCES COLOR ELECTRONICALLY, WHICH CAN MAKE COLORS SEEM BRIGHTER AND CRISPER.

depth of field

AS WE MENTIONED EARLIER, THE SMALL SIZE OF
A VIDEO CAMERA'S IMAGE SENSOR RESULTS IN
IMAGES WITH A GREAT DEAL OF FOCUS
DEPTH. IN FACT, SHOOTING WITH SHALLOWER
DEPTH OF FIELD IS ONE WAY VIDEO MAKERS
ATTEMPT TO ACHIEVE A "FILM LOOK." AN
ADVANTAGE TO SHOOTING FILM IS THE HIGH
DEGREE OF CONTROL YOU HAVE OVER D.O.F.
WHICH ISN'T TO SAY YOU CAN'T CONTROL
DEPTH WITH VIDEO... IT'S JUST TRICKIER.

motion blur

AT 24 FPS, A FILM CAMERA'S SHUTTER SPEED
IS SLOW ENOUGH THAT OBJECTS IN MOTION
TEND TO BLUR. THIS MOTION BLUR MAKES
MOVEMENT ON FILM SEEM SMOOTH, EVEN A
LITTLE DREAMY. THE HIGHER FRAME RATE
AND SHUTTER SPEED OF NTSC VIDEO
RESULTS IN LESS MOTION BLUR AND THE
SHARPER, "CLEANER" RENDERING OF
MOVEMENT. THAT SAID, THE VARIETY OF
FRAME RATES AND SCANNING METHODS NOW
AVAILABLE WITH VIDEO MEANS YOU CAN GET
EVERYTHING FROM FILMY BLUR (24p) TO
VIDEO CRISP (60i, 60p).

film to video

WHILE IT'S IMPORTANT TO NOTE THAT FILM
ISN'T VIDEO AND VIDEO ISN'T FILM, NOWADAYS
BOTH FILM AND VIDEO EXIST IN THE SAME
WORLD OF DIGITAL EDITING, EFFECTS, AND
IMAGE MANIPULATION. IT'S NO LONGER A
QUESTION OF FILM OR VIDEO, BUT FILM
AND VIDEO. IT'S NOW POSSIBLE TO CREATE
ALL SORTS OF HYBRIDS THAT MASH UP
WHAT'S GREAT ABOUT FILM WITH WHAT'S
GREAT ABOUT VIDEO.

brain tickler 6.

ACROSS

3. THE VIDEO CAMERA SETTING THAT ENSURES THE COLORS IN THE SCENE ARE CORRECTLY RENDERED (SEE 6 DOWN).

4. THE "PUPIL" OF THE VIDEO CAMERA; PRIMARY WAY TO SET EXPOSURE.

7. ZOOLOGICALLY-NAMED EXPOSURE HELPERS. (SEE 2 DOWN)

8. IT CAN CAUSE "NOISE" WHEN YOU BOOST IT.

DOWN

1. VIDEO CAMERA SETTING THAT CONTROLS STROBING AND BLURRING (SEE 5 DOWN).

2. SEE 7 ACROSS.

5. SEE 1 DOWN.

6. SEE 3 ACROSS.

the frame

ALL SHOTS ARE A COMPROMISE BETWEEN WHAT YOU DECIDE TO SHOW US AND WHAT YOU DECIDE NOT TO SHOW US. IN FACT, PART OF THE FUN OF MAKING A MOVIE IS DECIDING, MOMENT BY MOMENT, WHAT TO REVEAL AND WHAT TO CONCEAL.

SHOT SIZES RANGE FROM EXTREME CLOSE UPS THAT CAN SHOW THE DETAILS OF YOUR SUBJECT, ALL THE WAY TO EXTREME LONG SHOTS THAT CAN SHOW THE ENVIRONMENT THAT SURROUNDS YOUR SUBJECT.

EXTREME CLOSE UP (ECU) CLOSE UP (CU) MEDIUM SHOT (MS)

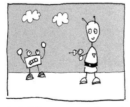

LONG SHOT (LS) EXTREME LONG SHOT (XLS)

SHOTS CAN BE TAKEN FROM DIFFERENT ANGLES.

LOW ANGLE

HIGH ANGLE

DUTCH ANGLE☆

☆ A HORIZONTAL TILT NAMED NOT FOR THE DUTCH BUT THE DEUTSCH EXPRESSIONIST FILMMAKERS WHO POPULARIZED IT IN THE 1920's.

OF COURSE, THE THING ABOUT MOVING PICTURES IS THAT THEY MOVE, AND SO CAN YOUR CAMERA...

A HORIZONTAL MOVE IS CALLED A PAN.

A VERTICAL MOVE IS CALLED A TILT.

Composition

COMPOSITION IS THE ARRANGEMENT OF
ELEMENTS IN THE FRAME. GOOD COMPOSITION
HELPS TO MAKE YOUR FOOTAGE MORE
VISUALLY INTERESTING TO WATCH.

WHAT MAKES GOOD COMPOSITION?

TO PARAPHRASE DUKE ELLINGTON, IF IT LOOKS
GOOD AND FEELS GOOD, IT IS GOOD! THAT
SAID, THERE ARE SOME GUIDELINES THAT
CAN HELP YOU MAKE GOOD COMPOSITIONAL
CHOICES.

the rule of thirds

THE "RULE OF THIRDS" IS A CLASSIC FORMULA FOR
COMPOSING YOUR IMAGE. IMAGINE THAT THE
FRAME IS DIVIDED INTO THIRDS, BOTH
HORIZONTALLY AND VERTICALLY.

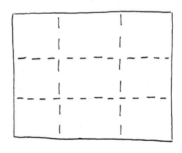

BY PLACING ELEMENTS AT THE POINTS OF INTERSECTION, YOU CAN CREATE A MORE DYNAMIC COMPOSITION.

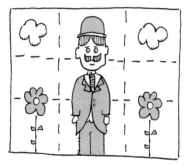

SYMMETRICAL AND STATIC

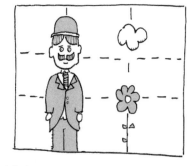

ASYMMETRICAL AND LESS STATIC

diagonals

ANOTHER WAY TO CREATE A MORE DYNAMIC COMPOSITION IS TO DIVIDE THE FRAME INTO A SERIES OF DIAGONALS ALONG WHICH YOU CAN ARRANGE VISUAL ELEMENTS.

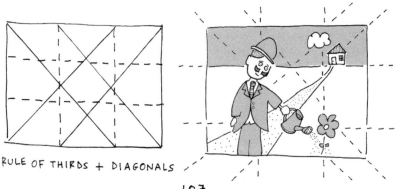

RULE OF THIRDS + DIAGONALS

weight

TO CREATE BALANCED COMPOSITIONS, KEEP
IN MIND THAT SOME VISUAL ELEMENTS
"WEIGH" MORE THAN OTHERS.

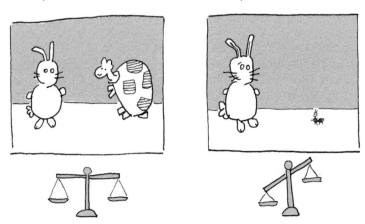

HARE AND TORTOISE HAVE ABOUT THE SAME
COMPOSITIONAL WEIGHT. FRAME THEM SIDE BY
SIDE, AND YOU GET AN IMAGE THAT IS
SYMMETRICAL AND BALANCED. NOW FRAME
HARE WITH ANT. BECAUSE HARE HAS SO MUCH
MORE VISUAL WEIGHT, THE COMPOSITION
SEEMS UNBALANCED.

IN FACT, BOTH THESE COMPOSITIONS COULD BE
IMPROVED BY TRYING SOME DIFFERENT
WAYS OF BALANCING THE VISUAL ELEMENTS.
FOR INSTANCE, IN THE FIRST SCENE, HARE
AND TORTOISE ARE BALANCED, BUT THE
OVERALL COMPOSITION IS STATIC AND A

BIT DULL. TO SPICE THINGS UP, YOU MIGHT
TRY PIVOTING THE CAMERA SO HARE IS IN
THE FOREGROUND AND TORTOISE IS IN THE
BACKGROUND. NOW THE VISUAL ELEMENTS
ARE BALANCED IN A MORE DYNAMIC WAY.

 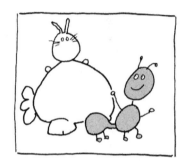

OR IN THE SECOND SCENE, TRY FRAMING
ANT IN THE FOREGROUND AND SHOOT
FROM A <u>LOW</u> ANGLE. NOW THE COMPOSITION
IS MORE BALANCED AND VISUALLY
INTERESTING WHILE STILL SHOWING US
THE DIFFERENCE IN SIZE BETWEEN ANT
AND HARE.

guiding the eye

ONE OF THE MAIN GOALS OF COMPOSITION IS
TO LEAD THE VIEWER'S EYE TO THE VISUAL
FOCUS OF THE FRAME. POOR COMPOSITION
WILL LEAVE THE VIEWER WONDERING
"WHAT AM I SUPPOSED TO LOOK AT ?! "

leading lines

ONE TRICK IS TO TRY TO FIND "LEADING LINES"
IN THE SCENE. THEY CAN BE ANYTHING —
ROADS, FENCES, TREE BRANCHES — THAT
LEAD THE VIEWER'S EYE TOWARD THE
SUBJECT.

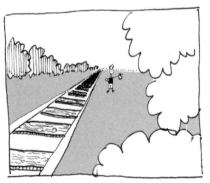

LEADING LINES GUIDE
OUR EYE TO THE FAR
DISTANCE WHERE WE
FIND OUR SUBJECT.
THEY ALSO CREATE A
SENSE OF PICTORIAL
DEPTH.

OTHER STUFF THAT CATCHES THE EYE:

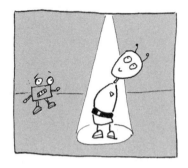

BRIGHTLY-LIT THINGS DRAW THE VIEWER'S EYE MORE THAN DIMLY-LIT THINGS.

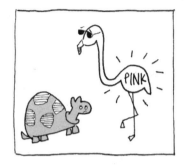

BRIGHT COLORS GRAB THE EYE MORE THAN DULL ONES.

contrast

CONTRAST IS THE RELATIONSHIP BETWEEN BRIGHT AND DARK PARTS OF THE IMAGE, OR BETWEEN DIFFERENT COLORS IN THE IMAGE.

WHITE BUNNY STANDING IN FRONT OF A SNOWDRIFT.

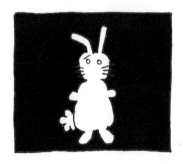

WHITE BUNNY STANDING IN FRONT OF A PILE OF CHOCOLATE.

IN A LOW CONTRAST COMPOSITION, VISUAL ELEMENTS TEND TO MERGE TOGETHER. IN A HIGH CONTRAST COMPOSITION, CERTAIN ELEMENTS SET THEMSELVES APART FROM OTHERS.

Frame within a frame

THE THING ABOUT FILM AND VIDEO FRAMES IS THAT THEY'RE ALWAYS RECTANGULAR, AND RECTANGLES CAN GET BORING! YOU CAN GIVE YOUR COMPOSITIONS A LITTLE PIZZAZZ BY CREATING FRAMES WITHIN THE FRAME. A FRAME WITHIN THE FRAME CAN BE ANY SHAPE YOU CAN IMAGINE.

A SHOT FROM SERGIO LEONE'S ONCE UPON A TIME IN THE WEST.

A SHOT FROM AGNÈS VARDA'S THE GLEANERS AND I.

shooting techniques

THE FIRST STEP TO SHOOTING IS FINDING YOUR SHOT. BEFORE YOU START ROLLING, LOOK AROUND. WHERE IS THE LIGHT COMING FROM? DO YOU HAVE A GOOD VIEW OF YOUR SUBJECT? ARE YOU IN THE BEST POSITION TO CAPTURE THE ACTION? EVEN WHEN YOU THINK YOU'VE FOUND YOUR SHOT, CHECK OVER YOUR SHOULDER. SOMETIMES, WHAT'S GOING ON BEHIND YOUR BACK IS MORE INTERESTING THAN WHAT'S GOING ON IN FRONT OF YOUR LENS.

JUST AS IMPORTANT AS WHERE YOU AIM YOUR CAMERA IS WHERE YOU POSITION YOUR MICROPHONE. AS A RULE, YOU WANT YOUR MIC TO BE AS CLOSE TO THE SOURCE OF THE SOUND AS POSSIBLE. IF THERE'S ONE THING THAT WILL IMPROVE YOUR FOOTAGE MORE THAN ANYTHING ELSE, IT'S TO GET GOOD, CRISP, CLEAN AUDIO.

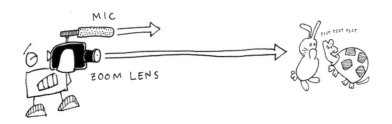

SO WHEN YOU'RE SHOOTING WITH A VIDEO CAMERA THAT HAS AN ONBOARD MIC, DON'T FORGET THAT EVEN THOUGH THE LENS CAN ZOOM IN ON STUFF THAT IS FAR AWAY, THE MIC CANNOT.

hand-held vs. tripod

SHOOTING WITH OR WITHOUT A TRIPOD IS BOTH A PRACTICAL AND AN AESTHETIC ISSUE. TRIPODS ALLOW YOU TO MAKE STABLE IMAGES, BUT THEY CAN BE A PAIN TO CARRY AROUND. SHOOTING "HAND-HELD" ALLOWS YOU TO BE MORE MOBILE, BUT YOUR IMAGES WILL BE SHAKY. AS A RULE :

SHOOT HAND-HELD WHEN YOUR SUBJECT IS IN MOTION. BECAUSE THE VIEWER'S EYE IS FOLLOWING THE MOVEMENT OF THE SUBJECT, SHE PAYS LESS ATTENTION TO THE SHAKINESS OF THE SHOT.

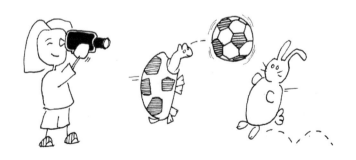

WHEN YOU SHOOT A STATIC SUBJECT,
THE SHAKINESS OF A HAND-HELD SHOT
IS MORE APPARENT, SO THAT'S A GOOD
TIME TO USE A TRIPOD.

← HA.

brain tickler 7.

ACROSS

2. THREE LEGS THAT STOP THE SHAKING.

3. COMPOSITIONAL ELEMENT THAT GUIDES OUR EYE INTO THE PICTORIAL DEPTHS (SEE 1 DOWN).

4. HORIZONTAL CAMERA MOVE

6. RELATIONSHIP BETWEEN BRIGHT & DARK PARTS OF SCENE.

10. THE E IN E.C.U.

12. SHOT TYPE NAMED FOR GERMAN FILMMAKERS WHO LIKED TO USE IT (SEE 5 DOWN).

DOWN

1. SEE 3 ACROSS
2. SEE 8 DOWN
5. SEE 12 ACROSS
7. SEE 8 DOWN
8. COMPOSITIONAL GUIDELINE THAT DIVIDES FRAME INTO HORIZONTAL AND VERTICAL SECTIONS (SEE 7 DOWN, 2 DOWN).

11. VERTICAL CAMERA MOVE.

9. AN OBJECT THAT FILLS THE FRAME HAS A LOT OF IT, COMPOSITIONALLY SPEAKING.

lighting

YOUR CAMERA CAPTURES LIGHT LIKE A NET CAPTURES BUTTERFLIES. YOU WANT TO FIND THE RAREST AND MOST BEAUTIFUL SPECIMENS YOU CAN!

characteristics of light

1. LIGHT CAN BE HARD OR SOFT. THIS IS KNOWN AS ITS QUALITY. HARD LIGHT IS DIRECTIONAL AND HAS CLEARLY DEFINED SHADOWS. SOFT LIGHT IS EVEN AND HAS DIFFUSE SHADOWS.

LIGHT ON A BRIGHT, CLEAR, SUNNY DAY IS HARD.

LIGHT ON AN OVERCAST DAY IS SOFT.

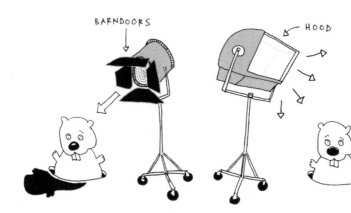

A SPOT LIGHT IS A
HARD LIGHT SOURCE.
THE SPOT'S STRONGLY
DIRECTIONAL BEAM
CAN BE FURTHER
SHAPED BY MOVABLE
METAL FLAPS ON THE
FRONT CALLED
" BARNDOORS. "

IN A SOFT LIGHT,
LIGHT FROM THE BULB
BOUNCES OFF THE
HOOD AND IS
DIFFUSED OR
"SOFTENED. "

2. LIGHTING CAN BE HIGH-CONTRAST OR
 LOW-CONTRAST. IN A HIGH-CONTRAST
 SITUATION, THERE'S A BIG DIFFERENCE
 BETWEEN THE BRIGHTEST AND THE
 DARKEST PARTS OF A SCENE. IN A
 LOW-CONTRAST SITUATION, THE
 DIFFERENCE ISN'T SO BIG.

 CONTRAST CAN BE EXPRESSED IN TERMS
 OF A LIGHTING RATIO BETWEEN THE

KEY LIGHT AND THE FILL LIGHT.

THE KEY LIGHT IS THE MAIN LIGHT SHINING
ON YOUR SUBJECT. THE FILL LIGHT FILLS
IN THE SHADOWS. BY ADJUSTING THE
AMOUNT OF KEY AND FILL, YOU CAN
ADJUST THE LIGHTING CONTRAST AND
CREATE DIFFERENT EFFECTS.

KEY : FILL

1 : 1

2 : 1

4 : 1

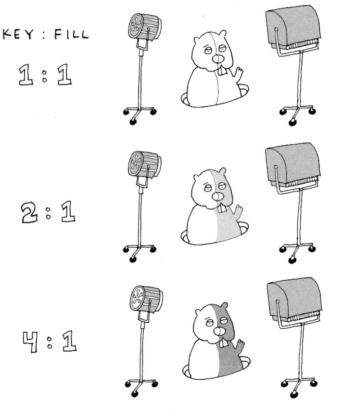

YOU CAN CHANGE THE MOOD OF A SCENE
SIMPLY BY CHANGING THE LIGHTING
RATIO. A BRIGHT, EVENLY LIT SCENE
WITH A LOW LIGHTING RATIO IS SAID
TO HAVE HIGH-KEY LIGHTING.

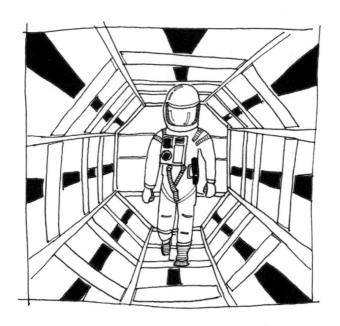

STANLEY KUBRICK USES HIGH-KEY
LIGHTING IN 2001: A SPACE ODYSSEY
TO EVOKE A GLOSSY, BRIGHTLY LIT
FUTURE.

LOW-KEY LIGHTING, WITH ITS HIGH
LIGHTING RATIO, IS SHADOWY AND
MOODY. YOU'LL OFTEN SEE THIS KIND
OF LIGHTING IN FILM NOIR MOVIES,
LIKE THIS SCENE FROM KISS ME DEADLY.

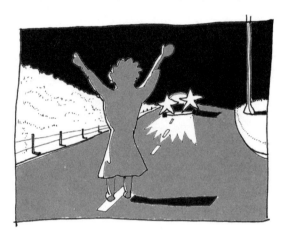

3. LIGHT CAN BE DIRECTIONAL.

FRONT BACK SIDE ABOVE BELOW

4. LIGHT HAS QUANTITY. THIS IS KNOWN AS ITS INTENSITY. YOUR LIGHT METER MEASURES INTENSITY IN TERMS OF FOOT CANDLES OR ITS METRIC EQUIVALENT CALLED LUX.

YOU CAN CONTROL THE INTENSITY OF LIGHT IN A FEW WAYS. YOU CAN ADD AND SUBTRACT LIGHT SOURCES:

OR YOU CAN MOVE THE LIGHT SOURCE CLOSER OR FARTHER FROM YOUR SUBJECT, OR YOUR SUBJECT CLOSER OR FARTHER FROM THE LIGHT SOURCE.

THE RELATIONSHIP BETWEEN INTENSITY AND DISTANCE IS DESCRIBED BY THE INVERSE SQUARE LAW, WHICH STATES THAT THE INTENSITY OF LIGHT

DECREASES BY 1 OVER THE SQUARE OF ITS DISTANCE FROM THE SUBJECT. IT'S EASIER THAN IT SOUNDS! FOR EXAMPLE, GROUNDHOG IS 1 FOOT AWAY FROM A LIGHT SOURCE, AND BUNNY IS 2 FEET AWAY. SO THE INTENSITY OF THE LIGHT ON GROUNDHOG IS $\frac{1}{1^2}$, OR 1, WHILE ON BUNNY, IT'S $\frac{1}{2^2}$, OR $\frac{1}{4}$.

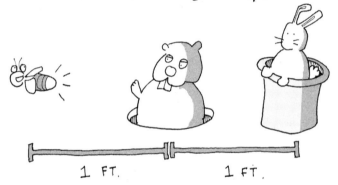

1 FT. 1 FT.

IN OTHER WORDS, BUNNY IS TWICE AS FAR FROM THE LIGHT AS GROUNDHOG, BUT THE INTENSITY OF THE LIGHT SHINING ON BUNNY IS ONE QUARTER AS BRIGHT AS THE LIGHT SHINING ON GROUNDHOG.

shaping light

LIGHT CAN BE BOUNCED, BLOCKED, COLORED
OR SHAPED IN A MILLION DIFFERENT
WAYS, DEPENDING ON THE LOOK OR
EFFECT YOU'RE TRYING TO ACHIEVE:

BOUNCE A HARD LIGHT OFF A WHITE WALL
OR CEILING AND, VOILÀ, YOU'VE GOT A
SOFT LIGHT:

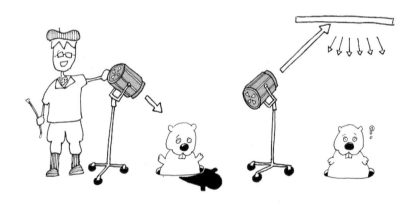

A BIG PIECE OF WHITE CARDBOARD CAN BE
USED AS A REFLECTOR TO FILL IN
SHADOWS...

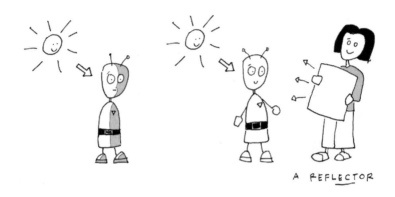

A REFLECTOR

A CUCULORIS, OR COOKIE, IS A PIECE OF
WOOD OR CARDBOARD WITH SHAPES CUT
OUT OF IT. WHEN YOU SHINE A LIGHT
THROUGH A COOKIE, IT CREATES A
PATTERN ON AN OTHERWISE
UNINTERESTING SURFACE.

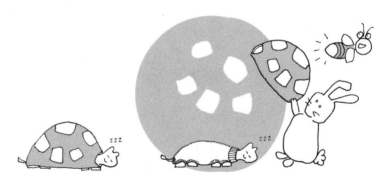

GELATIN FILTERS ("GELS") ARE COLORED PIECES
OF TRANSPARENT PLASTIC THAT YOU CAN PUT
IN FRONT OF A LIGHT, CHANGING ITS COLOR.
YOU CAN USE GELS TO CREATE ALL SORTS
OF EFFECTS. FOR INSTANCE, A BLUE GEL
IN FRONT OF A FLICKERING LIGHT SUGGESTS
THE GLOW OF A TV SET AT NIGHT.
REPLACE THE BLUE GEL WITH AN ORANGE
ONE, AND NOW YOU'VE GOT A CAMPFIRE!

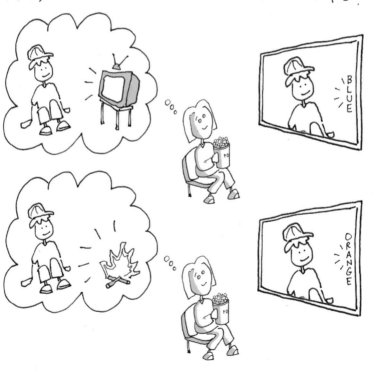

← HA.

brain tickler 8.

ACROSS

1. KEY : FILL
 (SEE 6 DOWN).

3. SEE 7 DOWN.

5. SEE 10 ACROSS.

8. EVEN LIGHT WITH
 DIFFUSE SHADOWS.

10. "LAW" THAT
 DESCRIBES
 RELATIONSHIP
 BETWEEN
 BRIGHTNESS &
 DISTANCE
 (SEE 5 ACROSS).

DOWN

2. IT'S MEASURED IN FOOT CANDLES.

4. PIECE OF MATERIAL WITH SHAPES CUT
 OUT ; CREATES LIGHTING EFFECTS.

6. SEE 1 ACROSS.

7. TYPE OF LIGHTING YOU MIGHT SEE IN
 FILM NOIR (SEE 3 ACROSS).

9. DIRECTIONAL LIGHT w/ STRONG SHADOWS.

audio

WE TEND TO TALK ABOUT MOVIES IN TERMS OF VISION. YOU DON'T GO "TO HEAR" A MOVIE, AFTER ALL, BUT "TO SEE" A MOVIE. WE PRIVILEGE THE VISUAL OVER THE AUDIBLE. BUT THINK ABOUT YOUR FAVORITE FILM. WHAT WOULD IT BE LIKE TO WATCH IT WITH THE SOUND TURNED OFF? THE FACT IS SOUND IS JUST AS IMPORTANT AS IMAGE WHEN YOU'RE MAKING A MOVIE. MAYBE EVEN MORE IMPORTANT. MY FRIEND DEB LIKES TO SAY THAT THE FILM IMAGE EXISTS IN ONE PLACE (THE SCREEN), BUT SOUND IS EVERYWHERE. WHEN WE WATCH (AND HEAR) A FILM, WE'RE WRAPPED UP IN IT.

what is sound, anyway?

SOUND IS ENERGY THAT TRAVELS THROUGH A MEDIUM (LIKE AIR) AS A WAVE. WHEN SOMETHING MAKES A SOUND, IT CAUSES MOLECULES OF AIR TO VIBRATE, I.E. TO ALTERNATELY BUNCH TOGETHER (COMPRESS) AND TO MOVE APART (RAREFY).

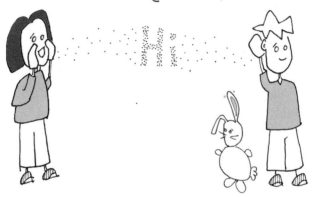

WHEN SOUND WAVES HIT YOUR EAR, THEY CAUSE YOUR EAR DRUM TO VIBRATE, WHICH IN TURN SENDS NERVE IMPULSES TO YOUR BRAIN, ALLOWING YOU TO PERCEIVE THE VIBRATIONS AS SOUND.

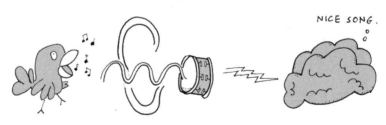

WHEN SOUND WAVES HIT A MICROPHONE, THEY CAUSE A DIAPHRAGM INSIDE THE MIC TO VIBRATE WHICH GENERATES AN ELECTRICAL CURRENT, OTHERWISE KNOWN AS THE AUDIO SIGNAL. THE AUDIO SIGNAL CAN THEN BE SENT TO AN AUDIO RECORDER.

IF THE LENS IS THE EYE OF YOUR CAMERA, THE MICROPHONE IS THE EAR.

microphones

MICROPHONES COME IN TWO MAIN FLAVORS : DYNAMIC AND CONDENSER. EACH HAS ITS ADVANTAGES AND DISADVANTAGES. DYNAMIC MICS DON'T NEED A BATTERY. THEY'RE RUGGED, RELATIVELY CHEAP, AND CAN HANDLE LOUD SOUNDS, BUT THEY'RE NOT VERY SENSITIVE TO SOFT SOUNDS.

CONDENSER MICS ARE MORE SENSITIVE THAN DYNAMIC MICS AND HAVE A GREATER FREQUENCY RESPONSE. THEY NEED A BATTERY, HOWEVER, AND THEY CAN'T HANDLE VERY LOUD SOUNDS.

ALL MICROPHONES ARE DIRECTIONAL, WHICH MEANS THEY'RE MORE OR LESS SENSITIVE TO SOUNDS ARRIVING FROM DIFFERENT DIRECTIONS. AN OMNIDIRECTIONAL MIC IS EQUALLY SENSITIVE TO SOUNDS ARRIVING FROM ALL DIRECTIONS. AN OMNI IS A GOOD

MIC FOR RECORDING AMBIENT SOUND.

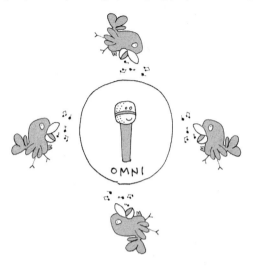

OMNI

A CARDIOID MIC, AS THE NAME SUGGESTS,
HAS A HEART-SHAPED PICKUP PATTERN. IT
IS SENSITIVE TO SOUNDS COMING FROM THE
FRONT BUT NOT THE REAR. THIS

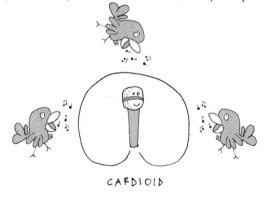

CARDIOID

ALLOWS YOU TO AIM THE MIC AT THE
SOUNDS YOU'RE INTERESTED IN RECORDING
(A CONVERSATION, FOR EXAMPLE).

A SHOTGUN MIC IS HIGHLY DIRECTIONAL, AND
THUS ALLOWS YOU TO BE HIGHLY SELECTIVE
IN RECORDING SOUNDS. A SHOTGUN IS
PARTICULARLY HANDY IN A NOISY SITUATION
BECAUSE IT ENABLES YOU TO ISOLATE THE
SOUND YOU WANT TO RECORD.

SHOTGUN

KEEP IN MIND THAT A MORE DIRECTIONAL MIC
DOESN'T "ZOOM IN" ON SOUNDS. IT JUST
NARROWS THE FIELD OF SOUNDS IT'S SENSITIVE

TO. THIS IS GREAT FOR CUTTING OUT
UNDESIRABLE SOUNDS, BUT DOESN'T HELP
MUCH IF THE DESIRABLE SOUNDS ARE TOO
SOFT. IN GENERAL, THE BEST WAY TO
RECORD SOUNDS IS TO GET AS CLOSE TO THE
SOUND SOURCE AS POSSIBLE.

audio recorders

FOR DECADES, PRODUCTION SOUND WAS
RECORDED ON MAGNETIC TAPE WITH ANALOG
AUDIO RECORDERS. REEL-TO-REEL TAPE
RECORDERS LIKE THE NAGRA WERE BUILT
LIKE TANKS AND DID A GREAT JOB. BUT
THEY ALSO WEIGHED A TON, AND JUGGLING
REELS OF MAGNETIC TAPE WAS FRANKLY A
HASSLE. THOUGH THAT OLD ANALOG GEAR WILL
BE MISSED, THERE'S NO DENYING THE
ADVANTAGES OF DIGITAL AUDIO RECORDERS:
THEY'RE LIGHT, THEY RECORD HIGH
FIDELITY SOUND WITH NO TAPE HISS, AND
YOU DON'T HAVE TO MESS WITH MAGNETIC
TAPE SINCE THEY RECORD STRAIGHT TO A
MEMORY CARD OR HARD DISK. BECAUSE
THE RECORDINGS ARE DIGITAL, THEY CAN
MOVE SEAMLESSLY AND WITH NO
GENERATIONAL LOSS FROM THE RECORDER
TO A DIGITAL EDITING SYSTEM.

audio recording: tips & tricks

THE GOLDEN RULE OF SOUND RECORDING IS TO POSITION THE MIC AS CLOSE TO THE SOUND SOURCE AS POSSIBLE. AS YOU CAN IMAGINE, THIS RULE HAS EXCEPTIONS. BUT IN GENERAL, IT'S A PRETTY GOOD RULE THAT WILL PRODUCE PRETTY GOOD RESULTS. IT IS ESPECIALLY IMPORTANT TO FOLLOW THIS RULE WHEN RECORDING DIALOG. VERY OFTEN, THE ONLY DIFFERENCE BETWEEN GREAT FOOTAGE AND UNUSABLE FOOTAGE IS WHETHER THE DIALOG IS WELL-RECORDED AND EASY TO UNDERSTAND OR NOT.

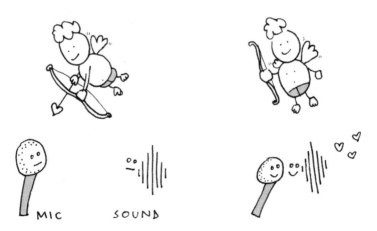

MIC SOUND

IT'S USUALLY A LOT EASIER TO RECORD HIGH QUALITY AUDIO IN A CONTROLLED SITUATION (ON A SET, FOR EXAMPLE) THAN IN AN UNCONTROLLED ONE (OUT IN THE FIELD, FOR EXAMPLE). IN EITHER CASE, GETTING GOOD AUDIO TAKES PRACTICE, PATIENCE, AND CONCENTRATION. HERE ARE A FEW SIMPLE TIPS AND TRICKS THAT MAY HELP:

HEADPHONES.

WHETHER YOU'RE RECORDING SOUND WITH YOUR VIDEO CAMERA'S ONBOARD MIC OR WITH A SEPARATE AUDIO RECORDING DEVICE, ALWAYS WEAR HEADPHONES. YOU WOULDN'T SHOOT VIDEO WITH YOUR EYES CLOSED, WOULD YOU?! IF YOU DON'T WEAR

TWEET!

HEADPHONES, IT'S LIKE SHOOTING WITH YOUR EARS CLOSED.

EXTENSION AND LAVALIER MICS

ALMOST ALL VIDEO CAMERAS HAVE AN ONBOARD MIC. THEY CAN BE USEFUL, ESPECIALLY IF YOU'RE SHOOTING ALONE IN AN UNCONTROLLED SHOOTING SITUATION. ONBOARD MICS AREN'T IDEAL, HOWEVER. FOR ONE THING, THE ONBOARD MIC AND THE CAMERA ARE JOINED AT THE HIP; WHEREVER THE ONE GOES, THE OTHER FOLLOWS. IF YOU WANT TO POSITION THE CAMERA AND THE MICROPHONE IN DIFFERENT PLACES, YOU'RE STUCK. ANOTHER PROBLEM IS THAT IN QUIET SITUATIONS, THE ONBOARD MIC CAN SOMETIMES PICK UP THE SOUND OF

THE CAMERA WHICH CAN BE DOWNRIGHT
ANNOYING. LUCKILY, THERE ARE A FEW
ALTERNATIVES.

A LOT OF VIDEO CAMERAS HAVE AN INPUT
FOR AN EXTENSION MICROPHONE. WITH AN
EXTENSION MIC, A MIC CABLE, AND A
SOUND PERSON, YOU GAIN A LOT OF
FLEXIBILITY. THE CAMERA CAN BE
POSITIONED FOR THE BEST VISUALS AND THE
MIC FOR THE BEST AUDIO. USING AN
EXTENSION MIC DOES HAVE ITS OWN
CHALLENGES. YOU HAVE TO BE CAREFUL
NOT TO GET TANGLED IN THE CABLE, AND
JOSTLING THE CABLE CAN RESULT IN CABLE
NOISE. YOU ALSO HAVE TO BE CAREFUL
TO KEEP THE MIC AND THE SOUND
PERSON OUT OF THE SHOT. A MICROPHONE
BOOM POLE CAN HELP...

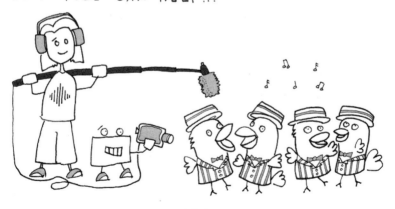

A GOOD WAY TO RECORD A SINGLE PERSON IS WITH A LAVALIER MICROPHONE (AKA, "LAV"). THIS KIND OF MIC CAN BE CLIPPED INCONSPICUOUSLY TO YOUR SUBJECT'S SHIRT. AN EVEN BETTER OPTION IS A WIRELESS LAV, WHICH USES A RADIO TRANSMITTER INSTEAD OF A CABLE. WITH A WIRELESS LAV, THE CAMERA CAN BE QUITE FAR AWAY FROM THE SUBJECT WHILE STILL RECORDING AUDIO THAT SOUNDS CLOSE AND CLEAR.

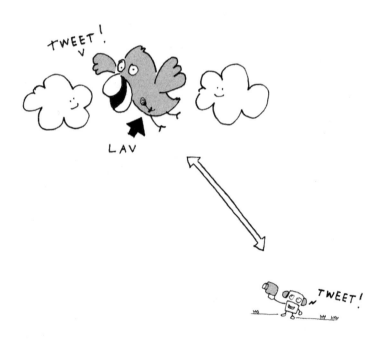

TWEET!

LAV

TWEET!

shooting wisdom

THE SECRET TO RECORDING GOOD IMAGES AND
SOUNDS, LIKE THE SECRET TO PLAYING A
MEAN GUITAR, IS PRACTICE. SO GO OUT
THERE AND GET SHOOTING. DON'T BE AFRAID
TO MESS UP, BUT ALWAYS PAY ATTENTION
TO WHAT YOU'RE DOING AND WHY YOU'RE
GETTING THE RESULTS YOU'RE GETTING.
WITH ENOUGH SHOOTING EXPERIENCE, YOU'LL
EVENTUALLY GAIN SHOOTING WISDOM, AN
INNATE SENSE OF HOW TO HANDLE ANY
SHOOTING SITUATION YOU FIND YOURSELF
IN.

- HA.

brain tickler 9.

ACROSS

3. EXTENDS YOUR REACH WHEN YOU'RE HOLDING A MICROPHONE.

6. MIC TYPE THAT NEEDS A POWER SUPPLY

7. AKA, A CLIP-ON MIC

8. WHAT A MICROPHONE CREATES WHEN IT PICKS UP A SOUND (SEE 4 DOWN).

9. A SOUND CAUSES MOLECULES OF AIR TO _____.

DOWN

1. MIC TYPE THAT DOESN'T NEED POWER.

2. DIRECTIONAL MIC USED BY A WELL-ARMED AUDIO HUNTER?

4. SEE 8 ACROSS.

5. SOUND RECORDIST'S EAR GEAR?

Appendix

HERE ARE A COUPLE PROJECTS TO GET YOU STARTED MAKING MOTION PICTURES EVEN IF YOU DON'T HAVE A CAMERA.

Chopstick Thaumatrope

THIS IS A VARIATION ON THE CLASSIC OPTICAL TOY THAT KEPT VICTORIAN KIDS OCCUPIED IN AN AGE BEFORE XBOX.

WHAT'S A THAUMATROPE? IT'S A LITTLE DISK WITH A PICTURE ON BOTH SIDES. WHEN YOU SPIN THE DISK, THE PICTURES APPEAR TO COMBINE. IN GREEK, "THAUMATROPE" MEANS SOMETHING LIKE "MIRACLE SPINNER" OR "WONDROUS TWIRLING THING." OF COURSE, IF YOU'RE A NEUROLOGIST, IT'S NOT A MIRACLE; IT'S JUST A NEURO-OPTICAL PHENOMENON. IT'S ALSO THE REASON WHY ALL THE STILL IMAGES THAT A MOVIE IS MADE OUT OF APPEAR TO US AS ONE CONTINUOUS

MOTION PICTURE. A MOVIE IS LIKE A
THAUMATROPE THAT SPINS AROUND 24 TIMES
A SECOND.

IT'S EASY TO MAKE. FIRST, CUT A COUPLE
CIRCLES OUT OF CARDBOARD. NOW DECIDE
WHAT TWO IMAGES YOU WANT TO COMBINE.
DRAW ONE IMAGE ON THE FIRST CIRCLE,
& THE OTHER ON THE SECOND. SANDWICH
THE CHOPSTICK BETWEEN THE TWO CIRCLES
WITH GLUE OR TAPE

SKEEETCH!

THAT'S IT! NOW RUB THE CHOPSTICK
BETWEEN YOUR OUTSTRETCHED HANDS &
WATCH THE MAGIC HAPPEN!

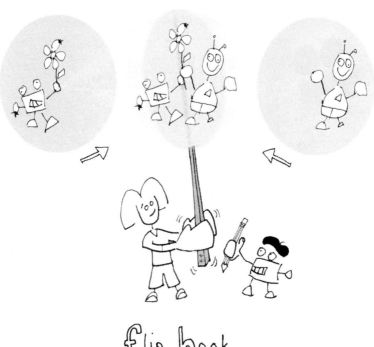

flip book

A FLIP BOOK IS LIKE AN ANIMATED MOVIE YOU
CAN KEEP IN YOUR POCKET. IT WORKS
ACCORDING TO THE SAME PRINCIPLE AS A
MOTION PICTURE: BY QUICKLY COMBINING
A SERIES OF STILL IMAGES, YOU CAN CREATE
THE ILLUSION OF MOTION.

FLIP BOOKS COME IN ALL SORTS OF SHAPES
AND SIZES. YOU DON'T EVEN NEED TO KNOW
HOW TO DRAW. YOU CAN MAKE A GREAT FLIP

BOOK WITH STICK FIGURES OR SIMPLE
GEOMETRICAL SHAPES.

FIRST, FIND A NOTEPAD OR A
NOTEBOOK OR EVEN AN OLD
PAPERBACK BOOK. THE
IDEA IS TO DRAW A
SERIES OF IMAGES
THAT WILL BECOME
ANIMATED WHEN YOU
FLIP THROUGH THE
PAGES. SOME PEOPLE
LIKE TO START WITH

THEIR LAST IMAGE FIRST. WHEN YOU START A
NEW DRAWING, YOU'LL BE ABLE TO SEE THE
IMAGE YOU ALREADY DREW THROUGH THE PAPER,
WHICH WILL HELP KEEP YOUR IMAGES LINED UP
(OR "REGISTERED," AS ANIMATORS SAY).

WITH SOME EFFORT,
YOU CAN CREATE
ALL SORTS OF
CINEMATIC EFFECTS:
ZOOMS, PANS,
TRACKING SHOTS —
YOU NAME IT. ONCE
YOU'RE DONE
DRAWING,
FLIP AWAY!

brain tickler key

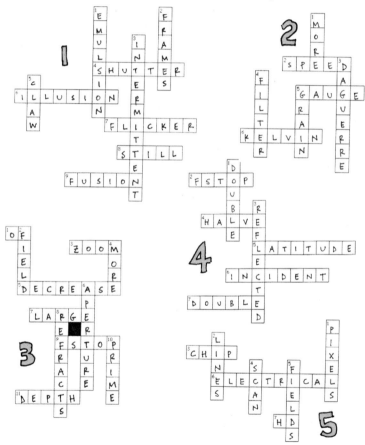

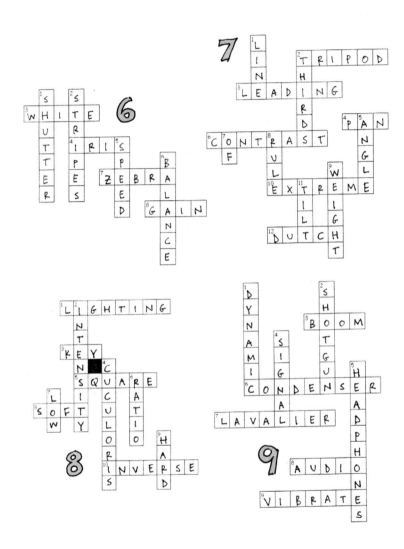

index